Musée *Yves Saint Laurent* Paris

Yves Saint Laurent

GOLD

ABRAMS, NEW YORK

This book is published on the occasion of the exhibition *GOLD by Yves Saint Laurent* at the Musée Yves Saint Laurent Paris from October 14, 2022 to May 14, 2023.

A Golden Year

MADISON COX

President of the Foundation Pierre Bergé–
Yves Saint Laurent

For the Foundation Pierre Bergé—Yves Saint Laurent, this has been an exceptional year that will surely resonate for many more to come. It has been a year of important anniversaries and historic milestones that with time will signify the vital impact and long-lasting influence of Yves Saint Laurent's vast body of work, which continues to fascinate and inspire new audiences and younger generations.

Sixty years ago, the twenty-five-year-old French couturier launched his first collection under his own name and a fashion house created with his life partner, Pierre Bergé. Forty years later, the couple closed their couture house and in 2002 created the Foundation Pierre Bergé—Yves Saint Laurent, which today houses the Musée Yves Saint Laurent Paris.

In the early months of this year, in commemoration of the sixtieth anniversary and in conjunction with five of the most prestigious Parisian museums, Yves Saint Laurent's creations were exhibited in dialogue with the nation's most coveted works of art from the permanent collections of the Musée du Louvre, the Musée d'Orsay, the Centre Pompidou, the Musée Picasso, and the Musée d'Art Moderne. This bold, far-reaching series of exhibitions underscored the unique force that the French couturier's work continues to exert and the unrivalled position he has held in the history of late twentieth century culture. This monumental project to cull creations from the vast storerooms of the Foundation was initially conceived by Mouna Mekouar, an independent curator, assisted by the cocurators Stephan Janson and myself. I take this opportunity to thank not only my cocurators but the entire team at the Foundation and the copartners at each of the five cultural institutions for this collaboration. It was a once-in-a-lifetime project that forged conversations, new friendships, and bonds of cooperation as the general visitor was invited to zigzag through galleries displaying vastly varied collections within each of the five participating Paris museums.

Equally unique to this year and equally vital to any institution has been the rejuvenation of the Foundation's mission, and this renewed sense of purpose is clearly exemplified with this exhibition, *Gold by Yves Saint Laurent*. It is with great pride that we acknowledge the curatorship of this exhibition and the fresh, innovative philosophy of Elsa Janssen, the recently nominated museum director. Working closely with the scientific team at the Musée Yves Saint Laurent Paris, along with an artistic committee comprised of Anna Klossowski and Valérie Weill, Janssen invited the contemporary Belgian artist Johan Creten, best known for his works in ceramics and metals, to exhibit selected pieces of his work in juxtaposition with some of the most iconic designs

by Saint Laurent. This notion of artistic dialogue, first explored in *Yves Saint Laurent aux Musées*, is an ongoing one and will be further developed in future endeavours. I thank you all deeply for taking on this challenging project and for the steadfast devotion you have all demonstrated throughout the course of this extraordinary exhibition.

While gold and all that glitters can signify exuberance and brilliance, not to mention great importance, it also has a festive and energetic quality that always captivated Saint Laurent, especially when displayed by those in his inner circle. It is extremely touching to revisit the images of those individuals, graciously loaned by Philippe Morillon, that capture the heady innocence of those decades long past.

This moving and dynamic exhibition, marked by crosscurrents of reference and meaning, is yet another example of the myriad textures and riches to come out of the life and work of Yves Saint Laurent.

Yves Saint Laurent, "Château Gabriel," Normandy, 1980.
Photograph by Lord Snowdon.

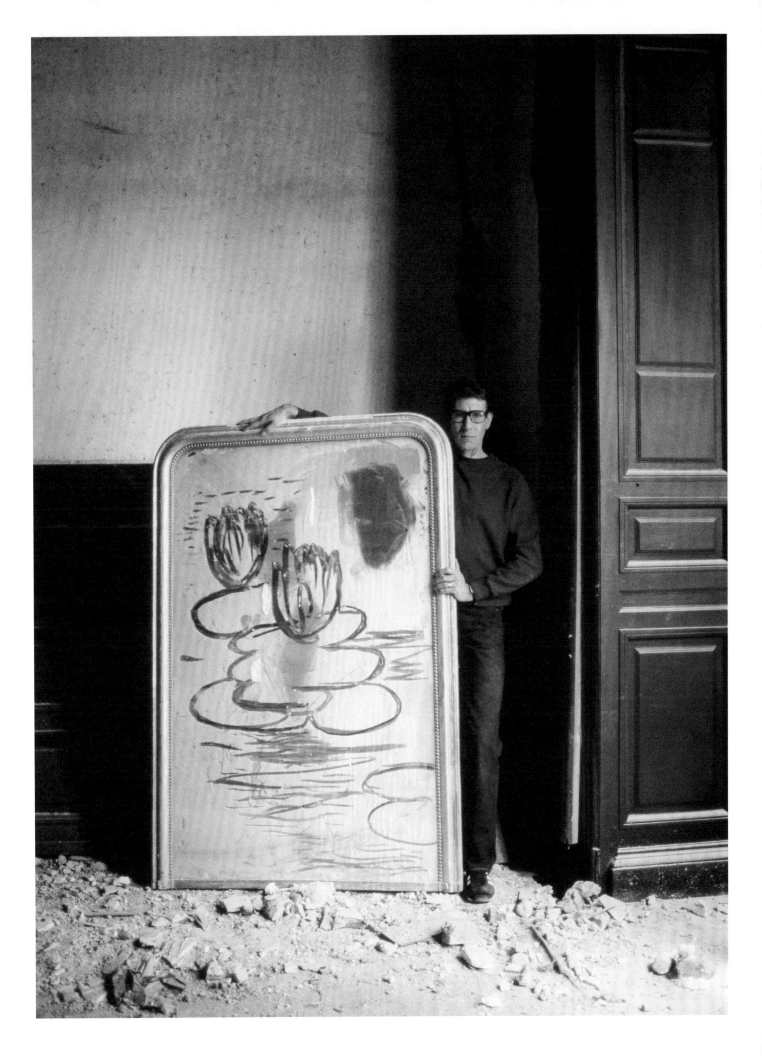

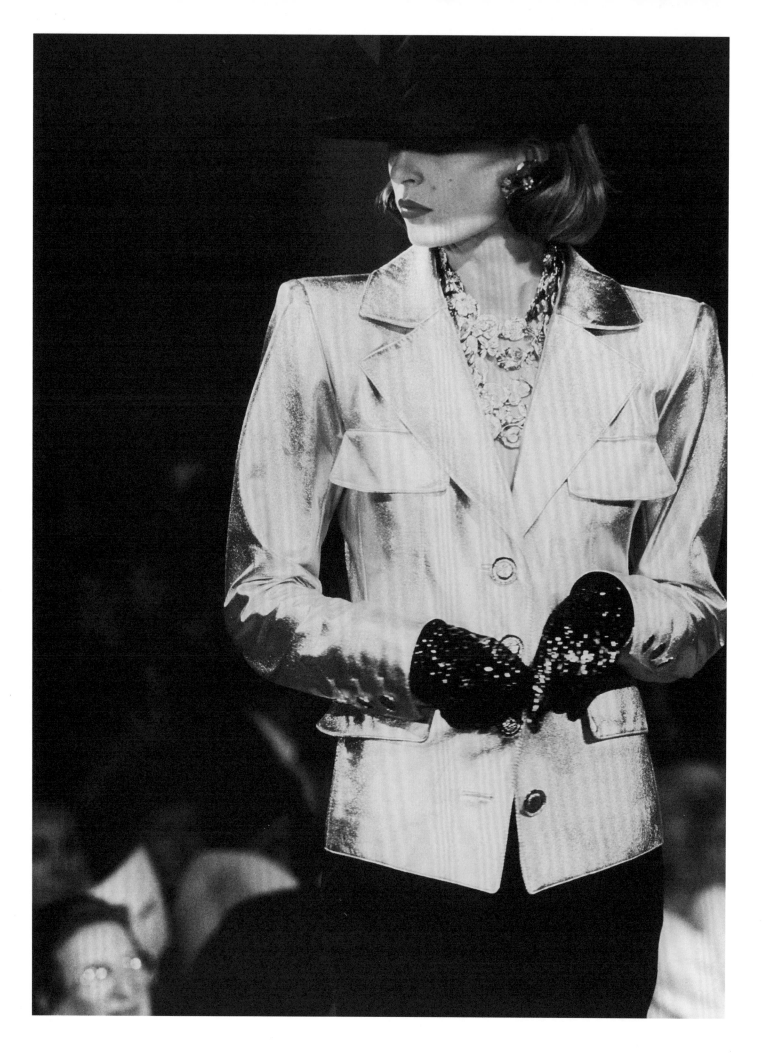

The Mark of Splendor

JOAN JULIET BUCK

Critic and writer, editor in chief of *Vogue* (Paris) from 1994 to 2001

I have long believed that Yves Saint Laurent brings luck.

His clothes gave us confidence, panache, and joy, and conferred a kind of luck that extended to our friends, acquaintances, and lovers.

Yves believed that sheaves of wheat were lucky. For Pierre Bergé, it was rain that was lucky, and he smiled broadly as he held his open palms up to the sudden downpour outside the new maison de couture at 5 avenue Marceau, on the day of its first couture show in 1974.

The many versions of gold in this exhibition bring back the brilliantly controlled exuberance of the designs that defined our personalities even before we had personalities, painlessly redesigned our bodies, raised our spirits and those of all around us, yet protected us from the jealousy they aroused.

Yves Saint Laurent's clothes gave us a dignity and an assurance that came from a world just out of reach, a world with its own laws, dreams, and rituals that were encoded into the unrelentingly disciplined shapes. This other place, which had started out as the child Yves Saint Laurent's imaginary theater, filled up with real people, places, and events, and became a living context, an absolute reality. There was Yves's inner circle of Pierre, Loulou, Clara, Betty, and Charlotte, and around it gravitated a group of friends who shared affinities of taste, color, and music, and a passion for Marcel Proust. The exclusive group became the context, intimate, private, yet highly visible. It was something more than fashion, more than society, more than culture. It was magic.

Gold is at the center of this magic. Gold is its raw material.

There was no shyness in Yves Saint Laurent's use of gold. He was not the first couturier to use gold, but he was the first to use it so boldly. It was always clear, always assertive. Gold was not simply an accent, trimming, or detail. For him, gold was a raw material that he handled fearlessly.

The neat lozenges of gold quilting, the blistered twisted scrolls of gold brocade, the matte hush of gold cloqué, or a rigid golden armor molded from the model's own breasts.

Look at this jacket: it's not gold leather, it's leather gold: smooth and solid, lustrous and slippery, with four plain patch pockets, worn like a work shirt, topped off with a plain black hat. It's an ordinary jacket that happens to be made of gold. You can almost hear it say "What are you looking at? Where I come from, we speak gold."

The most effective shells are the ones that reflect the light.

When I was very young, I had a pair of Yves Saint Laurent boots that were leather gold—not just gold leather, but leather gold. I wore them every single day, with everything, as if it were absolutely standard to wear gold boots. I wanted to make sure I knew, and to point out to others, that I belonged to the country where they speak gold.

When I begin to miss this other place too much and I'm in New York, I go to the collection of Renaissance armor in the Metropolitan Museum, to wander for a long time between the resplendent shells of the warriors of vanished empires.

Formal ensemble worn by Jutta, fall/winter 1986 haute couture collection. Photograph by Claus Ohm.

CONTENTS

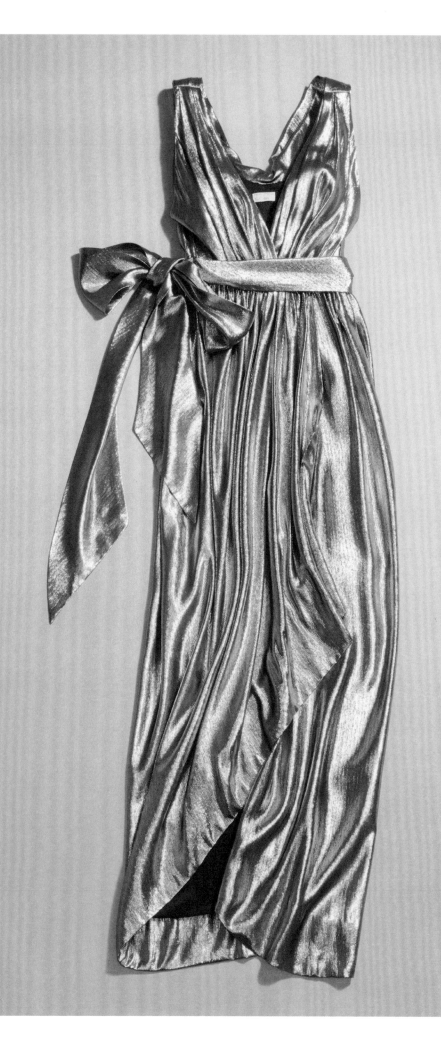

Yves Saint Laurent, Out of the Ordinary

ELSA JANSSEN
Director of the Musée Yves Saint Laurent
Paris

The collections of the Musée Yves Saint Laurent Paris abound with hidden treasures. More than five thousand haute couture pieces, more than five thousand accessories, and more than fifty thousand sketches testify to the forty years of collections from the couturier. Numerous heritage pieces reflect both the creative genius of the couturier and the process of creating haute couture collections.

Inspirations for an exhibition were abundant. While exploring the shelves of silhouettes preserved with great care in our storerooms, I suddenly realized that gold punctuated the haute couture collections of Yves Saint Laurent between 1962 and 2002.

Gold is material. Gold is color. Gold is light. Gold is without a doubt a color apart. And in the Musée Yves Saint Laurent Paris collections, gold is leather, Lurex, lace, and sequins. Thus, gold appears everywhere, whether as touches or as total gold. Here, a golden button; there, a leather coat. Here, a bust cast in galvanized copper; there again, a lamé gown that attracts the eye like a magnet.

The evidence was there. The exhibition *GOLD by Yves Saint Laurent* was a must. An exhibition is a collective adventure and a quest for the Holy Grail. Choices, sometimes difficult, must be made. Along with the museum's collection supervisors, we selected about forty works. Among the highlights are the jeweled dress, photographed by David Bailey for *Vogue* (Paris) in 1966—on the cover of the magazine are the words *Tout en Or* (*All in Gold*) (pg. 153)—the short sequined dresses worn by Zizi Jeanmaire and Catherine Deneuve (pgs. 148-49), and Sylvie Vartan's jumpsuit (pg. 131). Different themes emerged: emancipation, the celebration of women's power, the sense of spectacle, the Palace years, and the festive spirit.

Next it was necessary to think about the arrangements of these silhouettes, and it is during this process that fashion exhibitions can, and must, be renewed. I looked for inventiveness among talent with a special link to art and fashion. Anna Klossowski, an art publisher, has a unique fondness for Yves Saint Laurent. Daughter of Loulou de La Falaise and goddaughter of the couturier, she remembers skipping school and the beautiful moments playing among her mother's jewels and her godfather's fabrics. Anna has arranged more than three hundred jewelry pieces and accessories that she has selected from thousands. In addition, with her keen eye, set designer Valérie Weill pulled from the storerooms an intriguing braid of gold threads that originally accompanied the wedding dress of the fall/winter 1967 haute couture collection. She also chose necklaces with messages, joyfully displaying the words *parfum*, *aurore*, and *soleil*.

Evening gown, spring/summer 1995 haute couture collection. Variation made for the retrospective fashion show organized at the Stade de France for the final of the World Cup in 1998.

I also wanted to show these works in tune with today's creations because Yves Saint Laurent transcends eras. The sculptures in golden glazed stoneware by the Flemish artist Johan Creten speak to the golds of Yves Saint Laurent. The layout is orchestrated by the set designer Jasmin Oezcebi, who builds a subtle and contemporary journey that artfully transitions within the space of the legendary hôtel particulier on avenue Marceau.

The exhibition reflects the body; the book reflects the mind.

The book is both a reflection and extension of the exhibition *GOLD by Yves Saint Laurent*. Matthieu Lavanchy photographed some thirty silhouettes and accessories from the exhibition in shades of azure and gold. The blue transports us to a sunny, cloudless sky where nothing is hidden. And when the very young Yves Mathieu-Saint-Laurent declared to his mother, "One day, I will have my name inscribed in gold letters on the Champs-Élysées," who would have thought this foreshadowed the transformation of this young man, as shy as he was ambitious, into Yves Saint Laurent, a stylish signature of three letters, *YSL*, and a timeless icon?

To be director of the Musée Yves Saint Laurent Paris is to pursue Yves Saint Laurent's genius. It is to conduct an endless investigation into his personality, his talent. It is to attempt to understand his sources of inspiration and his obsessions, his tastes. In this book, I am in search of this unique and singular taste, a reflection of Yves Saint Laurent's aesthetic shadows: from the tutelary figures of Marie-Laure de Noailles to Elsa Schiaparelli to the flourishing universe of Christian Bérard and the Art Deco interiors of Jean-Michel Frank.

All the images and texts are interspersed with testimonies by those close to Yves Saint Laurent. This was an opportunity for them to leave their thoughts in a dedication to the couturier whom they admired. Thanks to Madison Cox, a close friend of Pierre Bergé and Yves Saint Laurent and president of the Musées Yves Saint Laurent in Paris and Marrakech, we were able to collect the words of thirty friends, former collaborators of the couture house, art dealers, and others. What a chance this was, and what a moving opportunity to hear them tell us about their moments spent with the couturier, whether through playful discussions or prolonged silences.

Joan Juliet Buck, the famous American fashion journalist, conveys the joy and enchantment of this iconic couture house, and a collection of never-before-published texts by writer Yvane Jacob unveils more about Yves Saint Laurent's personality through a prism of gold. All work to reveal the luminous, intimate, and public facets of Yves Saint Laurent the artist, the magician, and the dreamer.

To conclude, I would like to warmly thank Madison Cox for the trust he has placed in this project and for his support and valuable advice. I would also like to thank the entire museum team, who invested themselves in achieving this challenge in record time. I remain deeply amazed by their professionalism, competence, and enthusiasm.

Johan Creten, *ZWAM 3*, glazed stoneware, gold luster, 2019, unique work, 37 x 29 x 6 in (94 x 73 x 16 cm)

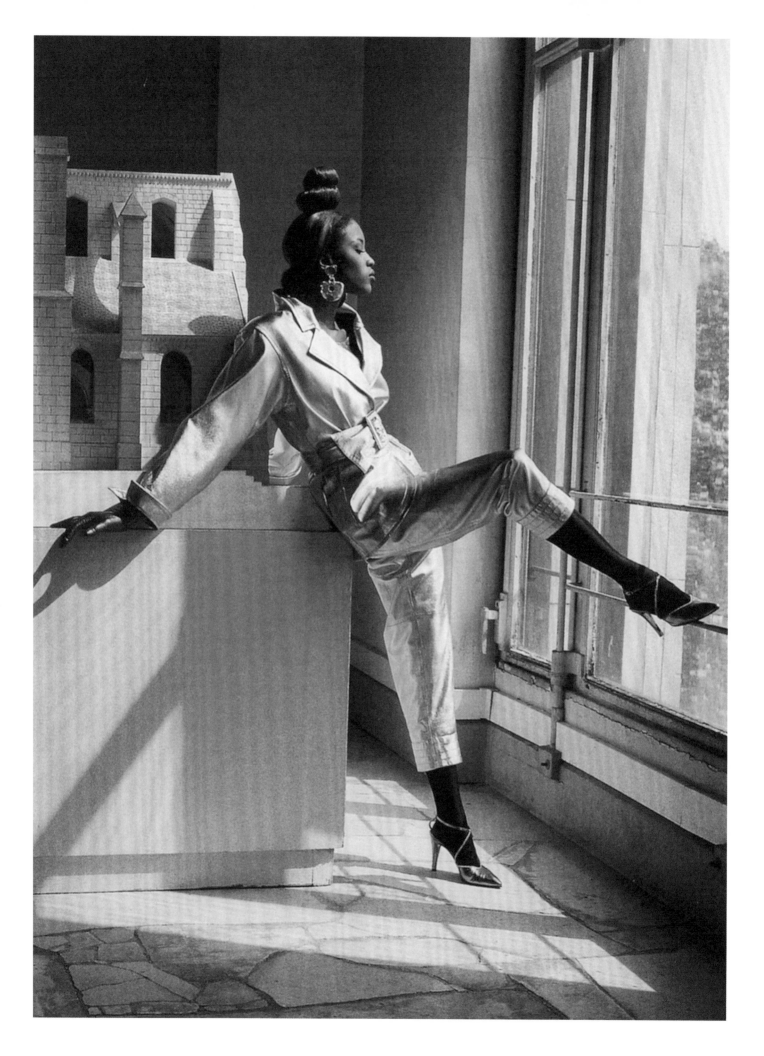

Gold, More Than Golden

ELSA JANSSEN
AND YVANE JACOB

In 1977, the annotation "GOLD" appeared on one of Yves Saint Laurent's research sketches. The exhibition dedicated to the couturier's golds borrows its title from this precious notation. This simple mention of gold, written in dark graphite, indicated the luminous color. On the other sketches, the word *or* (French for gold) was accompanied by a simple stroke of yellow, made with either a felt-tip pen or pencil; the color on the sketch didn't matter, because the fabric would do the rest. For the couturier, gold was not just a material. It was also, perhaps—and even especially—a color. With him, the metal transformed, its materiality disappearing in favor of its physical and symbolic representation. Yves Saint Laurent did not attach importance to the market value of gold but to the effect that something golden could produce. Instead of solid gold for his jewelry, the couturier preferred light materials that allowed him to play with their volumes. The visual aspect came before all else, for the assertion of a style.

For Yves Saint Laurent, what was golden was rich in meaning. It appeared in his fashion, it was omnipresent in his imagination, and he decorated his life in it. The term *gold* covered all aspects, as a keyword and as a password to understand and to draw, in our minds, a portrait of the creator, the radiant portrait of a solar personality in which light competed with dark. Gold was the antithesis to the color black, the other side of Yves Saint Laurent, which would have given rise to a completely different exhibition and a completely different book.

This book is intended to be an augmented vision of the exhibition. Whereas the exhibition focuses on the physical presence of gold in Yves Saint Laurent's work, this book is an opportunity to explore deeper into the worlds and inspirations of the couturier, the roots of his love for what was golden, which lead us back to Ancient Egypt, where gold was associated with the sun, eternal matter, and the flesh of the gods by which, in donning his funerary mask, Tutankhamun radiated even beyond death. Everything was represented in his fascinating sarcophagus: the sacred representation of royalty, eternal life, and the legends associated with them.

In his haute couture collections, Yves Saint Laurent associated gold with vivid colors, a happy marriage found on mosaics and Byzantine domes, on interfaces between the terrestrial world and the celestial world, and on religious paintings of gold leaf, the *fondo oro* of medieval Italy, and later in the "golden phase" of Gustav Klimt (the son of a goldsmith).

The sequin dress embroidered with multicolored stones, from the fall/winter 1966/1967 haute couture collection, chosen to illustrate the book and the exhibition, is a legacy of this celebration of gold in the history of art. And what about gold in the history of fashion? In 2020, archaeologists unearthed a piece of fabric dated to the fourth century, tinted purple and woven with gold threads. The fabric had almost disappeared, but the gold remained. This proved that the metal was not only used to embellish objects

and places, but it was also in clothing. Since those times, gold has not only continued to be worn, it has been transformed. Gold has become glamour.

In the 1930s, gold was represented in the evening gowns designed by Madeleine Vionnet and in the sheath dresses of Hollywood stars Rita Hayworth and Marilyn Monroe in the following decades. A passage from the ancient world to the modern world, from the sacred to the profane, from *or* to *GOLD*. The work of Yves Saint Laurent is the witness of this enduring heritage, mixed with varied references. Gold is an obvious theme that runs through his collections, a wonderful symbol for those who trace his life.

Among the many properties that are part of its precious character, gold can stretch almost indefinitely into a long, flexible, and unalterable thread. These characteristics evoke mythology, between legend and magic, and echo the personality of Yves Saint Laurent.

It all began in Oran, Algeria, his hometown, a city whose first two letters sound like a premonition made by the sun itself. This was a "resplendent city," according to the couturier, draped in a light and a heat that seemed to emit the color of gold. He had an affluent childhood—a "golden" childhood, as they say—divided between the city and the beaches along the coast where the family spent their holidays. The salt and sand, the waves that glimmered under the blinding sun—this was physical and sensual happiness. Yves was a "ray of sunshine," said his mother. He looked like it, with his golden skin and locks. As a young man, he read the most serious literature but also the fashion magazines he found at home. Did he ever come across this article in *Le Monde* published in 1947 when he was ten years old and whose title would certainly have caught his attention: "Paris Dresses the Nights of the World"? The text describes "a lamé dress" created by Edward Molyneux that dazzled "as much as a chandelier with 100 candles." From the other side of the Mediterranean, Yves Saint Laurent dreamed of the City of Light and drew stars on Emma Bovary's dresses, illustrating Flaubert's novel.

When Yves Saint Laurent was thirteen years old in Oran in May 1950, he attended a performance of *L'École des femmes*, directed by Louis Jouvet, with costumes and sets by Christian Bérard. It was his first great aesthetic immersion—and an artistic revelation. He soon after attended a play by Jean Cocteau, *La Machine infernale*, again with sets and costumes by Bérard. He was so inspired by these performances and these artists that they became paramount in the formation of his legendary taste. Christian Bérard also worked with Elsa Schiaparelli, for whom he created illustrations, and several of his works adorned the designer's interiors. These links, these characters, and these influences, which intersected and reintersected, illustrate for us the constellation that illuminated the couturier's beginnings. "In childhood, I contracted red and gold sickness," said Cocteau about his passion for theater and stage. A similar love was born in Yves Saint Laurent, a love of the golds and the glimmer of the stage that would make him hesitate between a career in fashion and a life dedicated to the theater. Upon his arrival in Paris in September 1954, it was at the Comédie-Française where the young fashion student was introduced, by

Michel de Brunhoff, editor in chief of *Vogue* (Paris), to the sets and costumes of Suzanne Lalique.

But the young Yves Saint Laurent was attracted by fashion. As modest and reserved as he was, he was aware of his talent. "I want to become a legend," he told his sisters as a child. His success happened sooner than he could have imagined. In June 1955, at age nineteen, Yves Saint Laurent met Christian Dior, again through de Brunhoff, and Dior hired him immediately. He left the École de la Chambre Syndicale de la Couture Parisienne, where he was studying. His designs were worth all the academic degrees in the world; they were gold in his hands. "In DIOR, there is God and there is gold," Jean Cocteau noted in his incomparable way.

Considering such a brilliant beginning, it was no surprise when success soon followed. Yves Saint Laurent designed his first collection at Christian Dior in January 1958. Pierre Bergé attended the show and met the couturier, but it was three days later when they would truly meet, at a dinner arranged by Marie-Louise Bousquet, a representative of the American magazine *Harper's Bazaar*. The name of the restaurant? La Cloche d'Or. Of course.

After the launch of the Yves Saint Laurent couture house, gold sparkled on the buttons of a peacoat, the star garment of his first collection in the summer of 1962. Gold continued to shine throughout his life. Gold appeared on the chairs of the Grand Salon of the InterContinental Hotel in Paris, where the couture collections were presented; in the bronze and vermeil objects of the fifteenth century acquired at the Kugel Gallery that were displayed in his homes; on the embroidered jacket of Diana Vreeland, who presented him with an award one evening in 1982 to celebrate the twenty years of the couture house; on the "300 most beautiful women in the world, covered in gold, silk, and light" (as stated by Pierre Bergé), who were part of the fashion show on the occasion of the 1998 World Cup at the Stade de France; and, of course, in the gold of the sun in Marrakech "that penetrates every crevice."

Yves "makes aesthetics of everything," said his accomplice day and night, Betty Catroux. The couturier sought to magnify life—his life. Yves Saint Laurent was a courier of gold who sought the beauty and the extraordinary in every moment.

Yves Saint Laurent created his designs on the concepts of opulence, splendor, and romanticism. Gold for him was never flashy; it was poetic. He surrounded himself with an extraordinary cast of characters, including Charlotte Aillaud, Paloma Picasso, Catherine Deneuve, Marie-Hélène de Rothschild, Hélène Rochas, and Andy Warhol. And with his "clan": Loulou de La Falaise, his sun, and Betty Catroux, his shooting star. For Loulou, gold translated into the skillful accumulation of jewels, both gilt and colorful, forming a treasure trove of elegance. Betty, Yves Saint Laurent's female counterpart, was made of this same mixture of light and shadow, beautifully translated by the black of her clothes and the sheen of her blond hair.

And then there's Pierre Bergé. Love is a divine theme; it has something golden in it. More prosaically, he was also the architect of Yves Saint Laurent's success and of the longevity of a company whose financial success was always

relevant. Greek and Roman mythologies teach us that gold is a perfect metal over which time has no hold; it is a sign of power, wisdom, happiness, prosperity, and Yves Saint Laurent knew how to prosper. He "built himself into an icon," writes Pierre Bergé, until he became one. When he arrived in Paris, he shortened his name, lending a sacred tone to it: Yves Matthieu-Saint-Laurent became Yves Saint Laurent. His success was thanks to his immense talent; the couturier was truly gifted. He had the aura of a star. He was a mix of charisma, restraint, audacity, and politeness, capable of making two impossible companions—scandal and elegance—coexist.

Yves Saint Laurent radiated light. Designated the "prince of fashion" by the press, he was crowned king in 1957 on the death of Christian Dior. His career was a reign of forty years paved with gold. This is evidenced by an award that he kept on the desk of his studio, next to piles of buttons, golden weaves, rolls of brocade and lamé fabric, the Dé d'or (Golden Thimble) that he received in 1993.

On January 22, 2002, for his farewell fashion show, Yves Saint Laurent placed a majestic domino on Carla Bruni's shoulders: a yellow cloak, the overwhelming color of the sun. On the day of his burial in the Church of Saint-Roch, on June 5, 2008, a piece of similar cloth, tied with sheaves of wheat, covered his coffin. He left this world shining.

The two Yves Saint Laurent museums, the first in Paris, the second in Marrakech, prove that the work of the couturier is now part of history. Through his creations, beauty was not his only ambition; he was also driven by the desire—the need, perhaps—to "do work," to make a mark on the history of clothing, fashion, and, therefore, on society. Like gold, his work never fades.

As a magician, Yves Saint Laurent designed, structured, and gave shape to this precious metal. As an artist, he surrounded himself with it. As a dreamer, he was intoxicated by everything that made life so brilliant. "There is a strength in me, a fierce will that pushes me toward hope and light," he confided. "I'm a fighter and a winner." It is the personality of this dazzling man that *GOLD by Yves Saint Laurent* sets out to explore.

Evening gown worn by Gloria Burgess, fall/winter 1978 haute couture collection. Photograph by Claus Ohm.

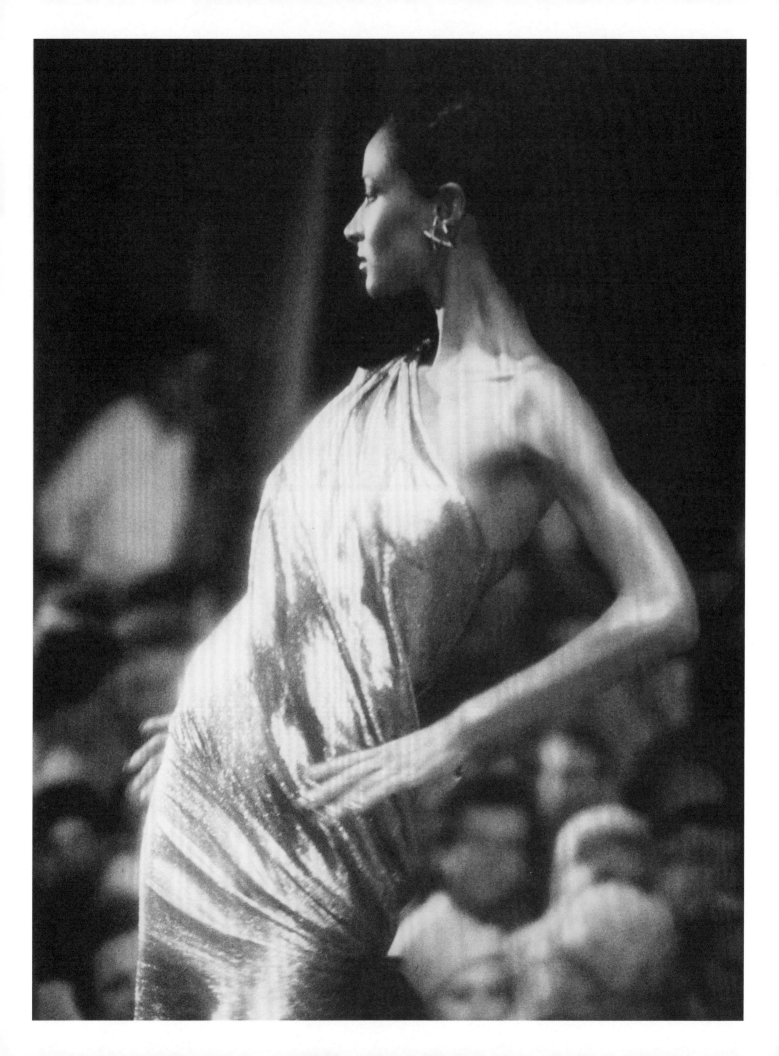

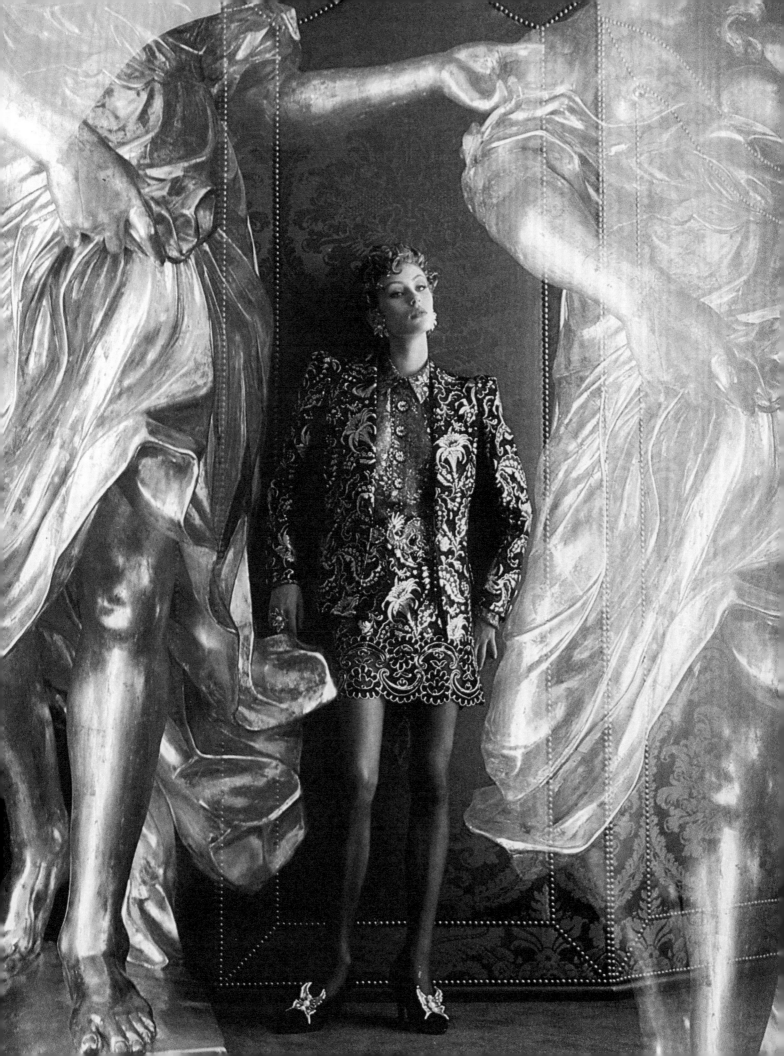

Yves Saint Laurent

ARTIST

Advertisement for fall/winter 1993 haute couture collection. Lamé damask and
guipure lace suit. Photograph by David Seidner, published in *Vogue* (Paris),
September 1993

Maria Casarès pushes open the door of her apartment, sad, weary, and splendid in her couture gown. Her lover, Jean, neglects her. She feels it. For their anniversary, she hands him a gift, a pretty box that appears to be gold by its gleaming brilliance, and he responds: "I love gold, it looks like you, hot, cold, bright, dark, incorruptible."[1] We can imagine Yves Saint Laurent writing down this sentence in his mind: *Les Dames du bois de Boulogne*, released in 1945, was one of his favorite films. Madame Grès and Elsa Schiaparelli designed the costumes, Jean Cocteau the dialogue. It was Gabrielle Chanel who introduced the writer to director Robert Bresson. Yves Saint Laurent could only be impressed by this incredible ensemble of talent. Cinema, like all the arts, inspired him. But it was more than that. Art was, for him, an essential value of life. And just as gold ran through his work, it was also a reference, a tribute, to all the artists who preceded him. Gold was omnipresent in the tombs of the pharaohs of ancient Egypt, a marvel in Byzantine mosaics, "the sweat of the sun god"[2] for the Incas, and a treasure for the Achaemenids, the first ancient Persian dynasty. Gold decorated jewelry, vases, tools, and weapons. Gold escorted the dead to their final resting place and was offered to the gods in religious rituals. Gold dressed the liturgical objects, illuminated the altarpieces on the walls of churches, and flooded the sacred scenes of medieval Italy with sunshine. The couturier was imbued with these holy images: "Visually, the church was of great importance to me, because it was in the cathedral that all the important masses took place, with the sumptuous chasubles. The candles, the incense, it was 'magical.'"[3] The couturier reflected this brilliance in his own way when, one day in 1985, a priest asked him to create a robe for a statue of the Virgin Mary in the small church of Notre-Dame-de-Compassion in Paris's 17th arrondissement. A golden dress, grandiloquent, radiant, like those of the Madonnas that the faithful carry proudly, held up at arm's length, in the streets of Andalusia.

To live, Yves Saint Laurent needed to surround himself with splendor. He had several prominent mentors: Marie-Hélène and Guy de Rothschild, owners of the sumptuous Château de Ferrières, and Marie-Laure and Charles de Noailles, whose elegant mansion located on the Place des États-Unis in Paris, was "one of the pivotal houses regarding the history of good taste in the twentieth century," as Philippe Jullian described it in an article in the magazine *Connaissance des arts*, published in October 1964. This house could constitute Yves Saint Laurent's personal pantheon, as he admired the artists it welcomed in a bold and harmonious mix of genres. There were masterpieces of art history and contemporary pieces by Francisco de Goya, Edward Burne-Jones, Antoine van Dyck, Pablo Picasso, and Georges Braque. It was an inventory that foreshadowed the collection that Yves Saint Laurent and Pierre Bergé would slowly build throughout their life together. The couturier described the de Noailles' smoking room and salon as the "eighth wonder of the world."[4] These rooms were decorated in the 1920s by Jean-Michel Frank, close to Alberto Giacometti and Christian Bérard. The latter, an artist of infinite talents, was not only a costume designer but a painter, illustrator, and decorator. Yves Saint Laurent was fascinated by his work, as was the decorator Jacques Grange, who nicknamed him "l'homme à la cervelle d'or"[5] (the man with the golden brain), after the title of a short story by Alphonse Daudet. The expression

1 Robert Bresson, *Les Dames du bois de Boulogne*, 1945.
2 François Pernot, *L'Or, Chamalières: Artémis*, 2004.
3 *New York Times*, December 4, 1983.
4 Laurence Benaïm, *Jean-Michel Frank. Le chercheur de silence*, Paris: Grasset, 2017.
5 Laurence Benaïm and Pierre Passebon, *Christian Bérard, excentrique Bébé*, exhibition catalogue, Nouveau Musée National de Monaco, Paris: Flammarion, 2022.
6 Yves Saint Laurent in *Le Monde*, September 18, 1977.
7 Yves Saint Laurent, exhibition catalogue, Metropolitan Museum of Art, Costume Institute, New York, 1983.
8 *Les Dessins d'Yves Saint Laurent*, documentary by Loïc Prigent, 2017.

is a reference to his extreme kindness, certainly, but the coincidence is worth mentioning. Gold, always gold. For the decor of the Château Gabriel, a manor house Yves Saint Laurent and Pierre Bergé purchased overlooking the bay of Deauville, they reached out to Jacques Grange. He was asked to re-create an atmosphere worthy of the characters in Marcel Proust's *In Search of Lost Time*. Like Proust, who built a land of pure fantasy in his writing, where *Arabian Nights* and the impressionist landscapes of Claude Monet mingled, Yves Saint Laurent created palaces populated by extraordinary characters, guided by his dreams and his poetry, where Ludwig II of Bavaria, the architect of fairy-tale castles inspired by Versailles, came together with the divine Maria Callas, "unreal, vaporous, fairy floss."[6] Yves Saint Laurent's interiors are the culmination of a long period of observation and the evolution of his taste. At his home on rue de Babylone, there was a clever juxtaposition of Renaissance bronzes from the Kugel Gallery with Art Deco pieces, including Eileen Gray's masterpiece, the "Dragons" armchair. In the Normandy manor house was the warmth of velvet, golden curtains, and oriental carpets, in a spirit of fin de siècle opulence borrowed from Luchino Visconti and his film *L'Innocente*, another film that impacted Yves Saint Laurent. "Like F. Scott Fitzgerald, I like decadent frenzy"[7] said Yves Saint Laurent. It's a long history of accumulation and nostalgia, the splendor of the past miraculously applied to current styles.

At the age of twenty, the couturier met Claude and François-Xavier Lalanne, who were responsible for decorating the windows of the Christian Dior couture house. The two sculptors lived in a world of their own, populated by fantastic beasts and furniture with influences alternately surreal, rococo, and Art Nouveau. Yves Saint Laurent and Pierre Bergé ordered a bar from the sculptors for their first apartment at Vauban; then the couturier invited Claude Lalanne to collaborate on his collections. The sculptor designed jewelry, necklaces with vegetal and animal motifs, and incredible golden busts, which, when combined with blue and black chiffon, formed more than just dresses but works of art. This was the first time that an artist collaborated with Yves Saint Laurent. Unlike Schiaparelli, the couturier was not used to working directly with other creators. He was inspired by them, paid tribute to them in the name of beauty, but always worked independently. His collections were a way to give substance to his dreams and inspirations—to make the colors of Henri Matisse and pop art, the motifs of Pierre Bonnard, and the lines of Piet Mondrian dance before our eyes. Yves Saint Laurent had an incredible talent for sketching and a great sense of color that is reflected in his work. The couturier used his fabric samples the way a painter uses his palette. He tried everything, under the sometimes puzzled gaze of his studio. "He's not going to mix that, is he?"[8] whispered Mrs. Catherine, the *première* of the atelier. Yes, he is, and it will be successful! The outfits of the women of Marrakech encouraged him to dare with combinations of purple, turquoise, fuchsia, and blue. Yves Saint Laurent was filled with wonder. He had a keen eye that was focused everywhere and recognized art, absorbed it, and transformed it. And what of gold? It was Vincent van Gogh's *Sunflowers* that Yves selected to embroider on a jacket where the flowers would never fade.

Yvane Jacob

"You had genius. I knew to come along with you, and this collection that we made together allowed me to be close to the 'thieves of fire' of which Rimbaud wrote. You know that I can't thank you enough for taking me with you to the peaks of creation."

Pierre Bergé,
Lettres à Yves,
February 15, 2009

Yves Saint Laurent and Pierre Bergé in their apartment at 55 rue de Babylone, Paris, 1982. Photograph by Vladimir Sichov.

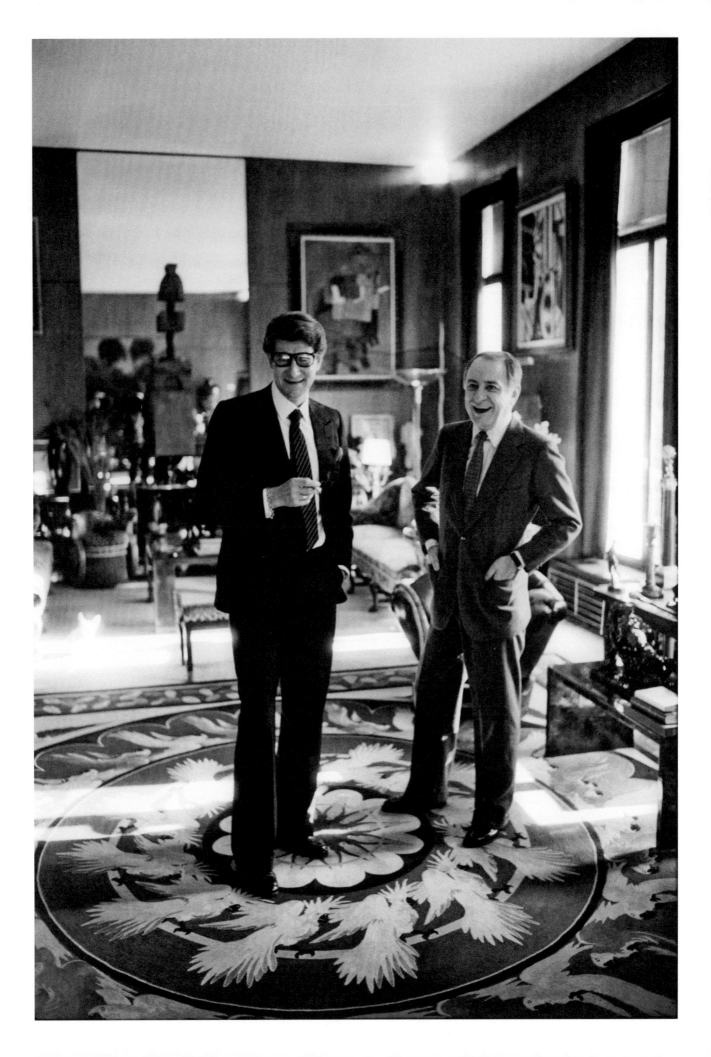

The collection

"We loved art, and we wanted to live surrounded by works of art without worrying about pleasing anyone or being fashionable," says Pierre Bergé. Thus, with Yves Saint Laurent, they collected *objets d'art* that furnished their apartment on rue de Babylone, the Château Gabriel, and their house in Marrakech. Their first acquisition together dates back to 1960. It was a large Ivorian sculpture called *The Senufo Bird*. This work was one of the few that Pierre Bergé decided not to part with when selling their collection in 2009. With its 733 lots, the collection was described as the "sale of the century."

In the same vein as collectors such as Jacques Doucet or the de Noailles, Pierre Bergé and Yves Saint Laurent collected various œuvres. Throughout their home were sculptures, paintings, drawings, goldsmiths' objects, and decorative arts ranging from antiquity to impressionism. In their collection, Roman busts rubbed shoulders with bronze and vermeil steins, engravings by Francisco de Goya, tapestries by Edward Burne-Jones, sketches by Edgar Degas, sculptures by César, paintings by Piet Mondrian and Andy Warhol, and works commissioned from contemporary artists such as Lalanne. M.D.

César, *L'Homme de Draguignan*, bronze with gold patina, 1957, from the Pierre Bergé–Yves Saint Laurent collection.

Following spread:
Edward Burne-Jones, *L'Adoration des mages*, 1904, high-warp tapestry, wool and silk on cotton weft, Musée d'Orsay, from the Pierre Bergé–Yves Saint Laurent collection.

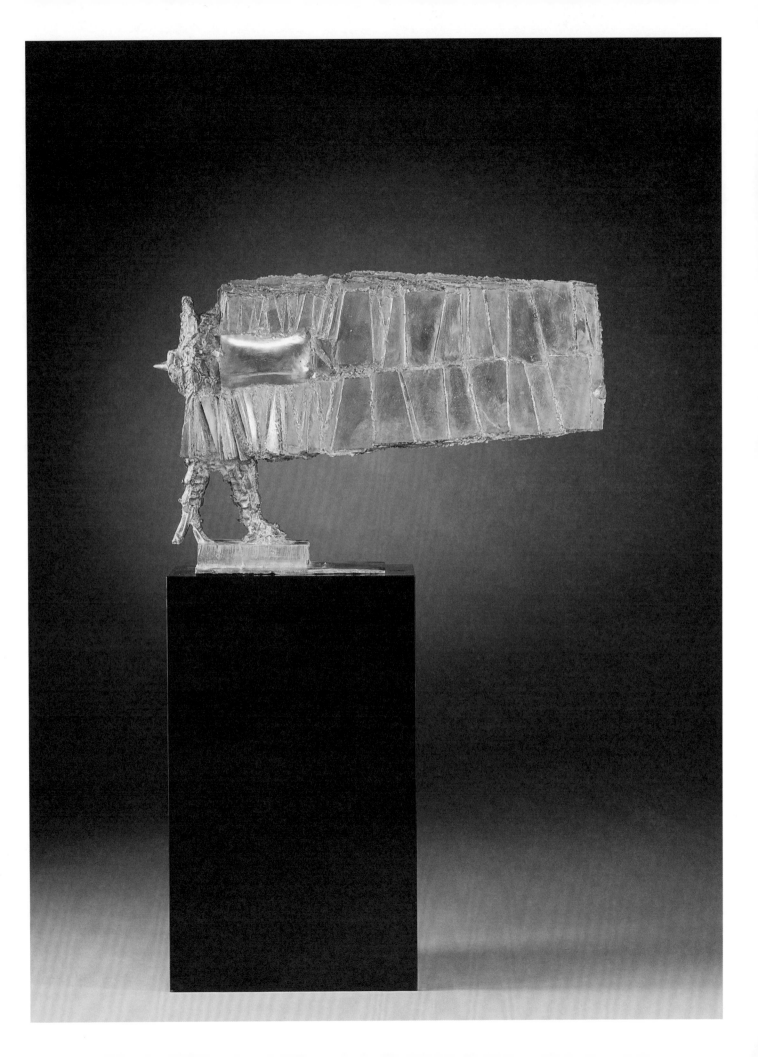

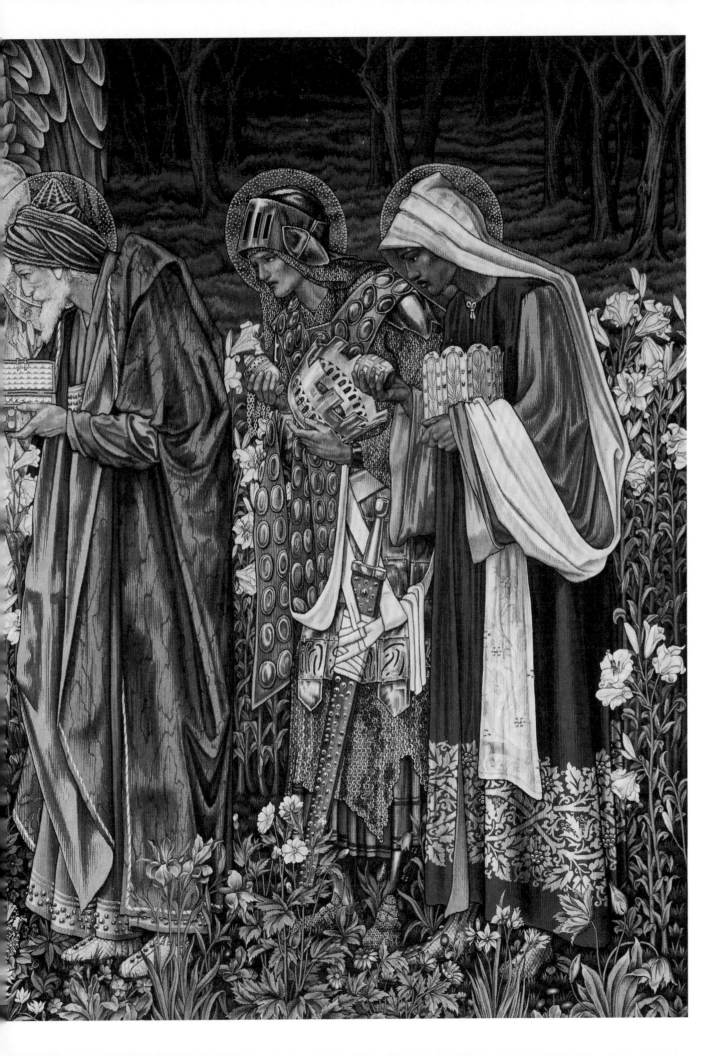

A Grand Feat!

Gold, perceived as a sign of wealth, power, and prestige, has often been associated with deities and reserved for the powerful. Yves Saint Laurent made subversive use of these connotations by popularizing gold among women. Throughout his career, the couturier drew his inspiration from this precious material and appropriated its symbolism to draw a "ceremonial portrait" of the modern woman who, in elegant and contemporary creations, would portray an aura of influence and a kind of "sovereignty": proud, confident, self-assured. More than just an aesthetic effect, gold became a manifesto of feminine power.

Its brilliance, associated with the sculptural aspect of black, the richness of textile materials, artful techniques, and the particular cut of some silhouettes, makes reference to the Baroque style (seventeenth to eighteenth centuries) and its grand decors, such as that of the Hall of Mirrors in Versailles. At the same time monumental, dynamic, and ostentatious, the Baroque movement was the ideal backdrop for staging the power and celebration of French *savoir faire*. "My fantasy, my pronounced imaginative gifts move me . . . toward the Baroque," stated Yves Saint Laurent.

Inspired by the Sun King's penchant for grandeur, Yves Saint Laurent also took hold of this radiant style to enhance the female body and reveal its solar force. After all, what does gold evoke for us if not sun, light, heat, and by extension joy, energy, and life? Imbued with majesty and vitality, the Yves Saint Laurent wardrobe confirmed the power of women, immutable and timeless, like the precious metal that dressed them. J. L.

Evening ensemble worn by Nicole Dorier, fall/winter 1982 haute couture collection. Photograph by François-Marie Banier.

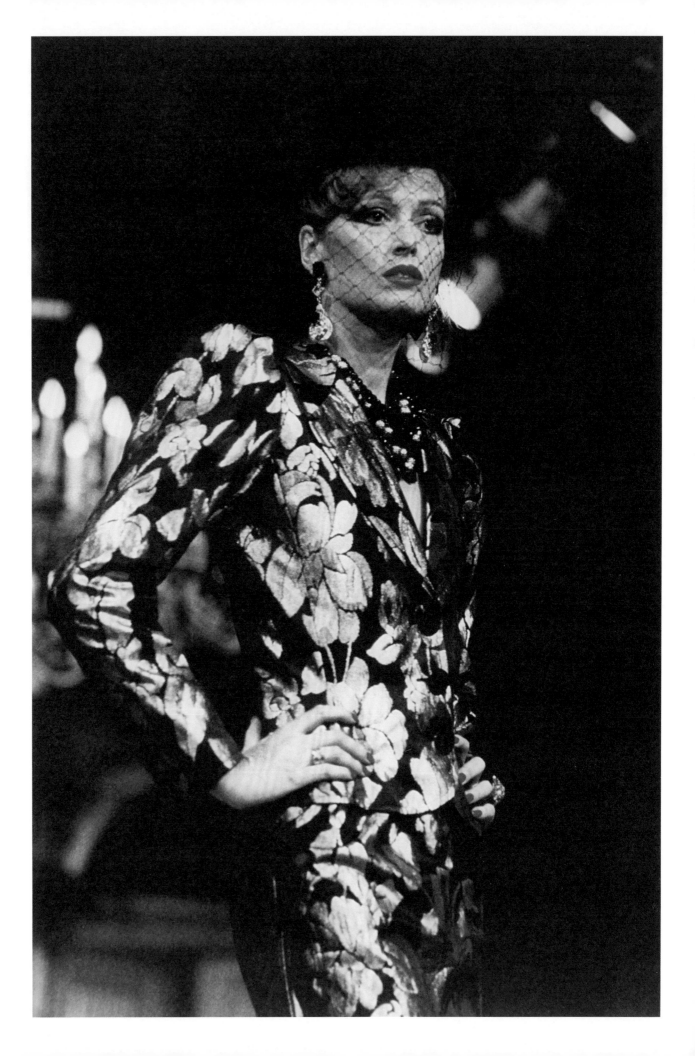

Original sketch of an evening ensemble, fall/winter 1979 haute couture collection.

Damask evening ensemble, fall/winter 1979 haute couture collection.

"For his interiors, Yves Saint Laurent clearly shared with me his aesthetic convictions, often through artistic, cinematographic, and literary references. For Deauville, he wanted each room to evoke a character from Proust's *In Search of Lost Time* and often quoted Visconti's film *L'Innocente*. For the couture house, he assertively declared that he wanted emerald green, a large gilded mirror, and chandeliers as were in Bérard's sets for *La Belle et la Bête*."

Jacques Grange

The couture house salon at 5 avenue Marceau, Paris, decorated by Jacques Grange in 1996.

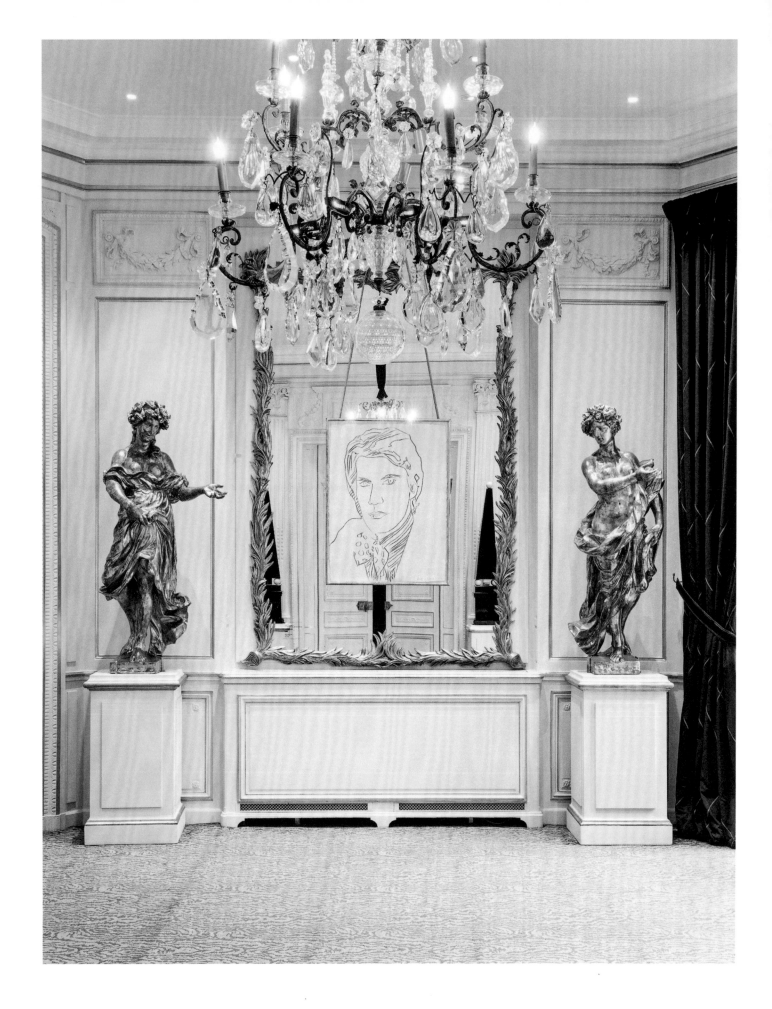

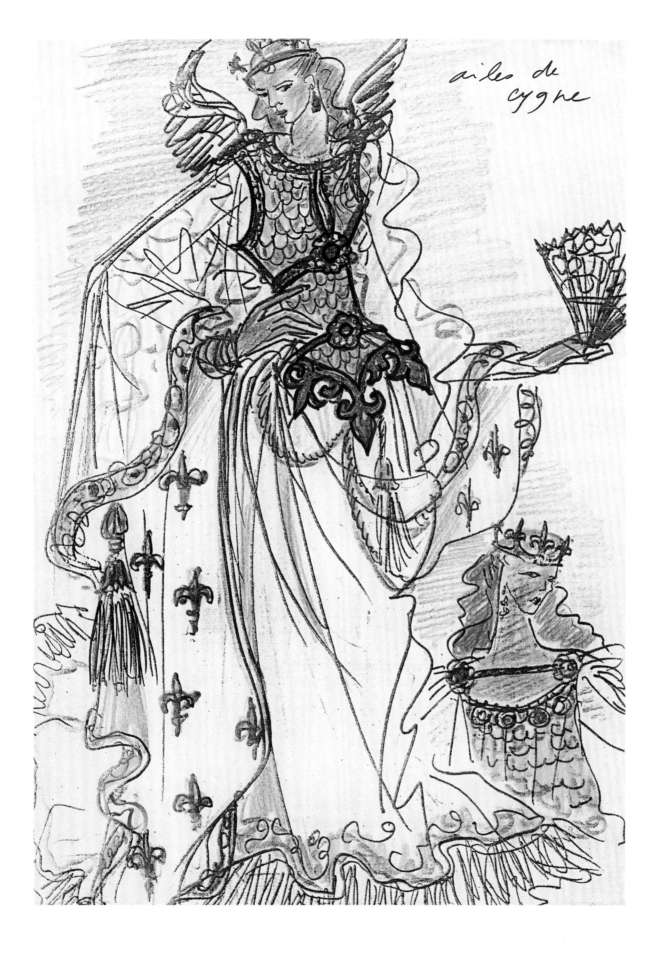

ailes de
cygne

Queen's costume sketch for Act I of *L'Aigle à deux têtes*
by Jean Cocteau, directed by Jean-Pierre Dusseaux
at the Athénée Théâtre Louis-Jouvet, 1978.

Dress worn by Jerry Hall. Photograph by Norman Parkinson, published in
Vogue (Great Britain), September 1975.

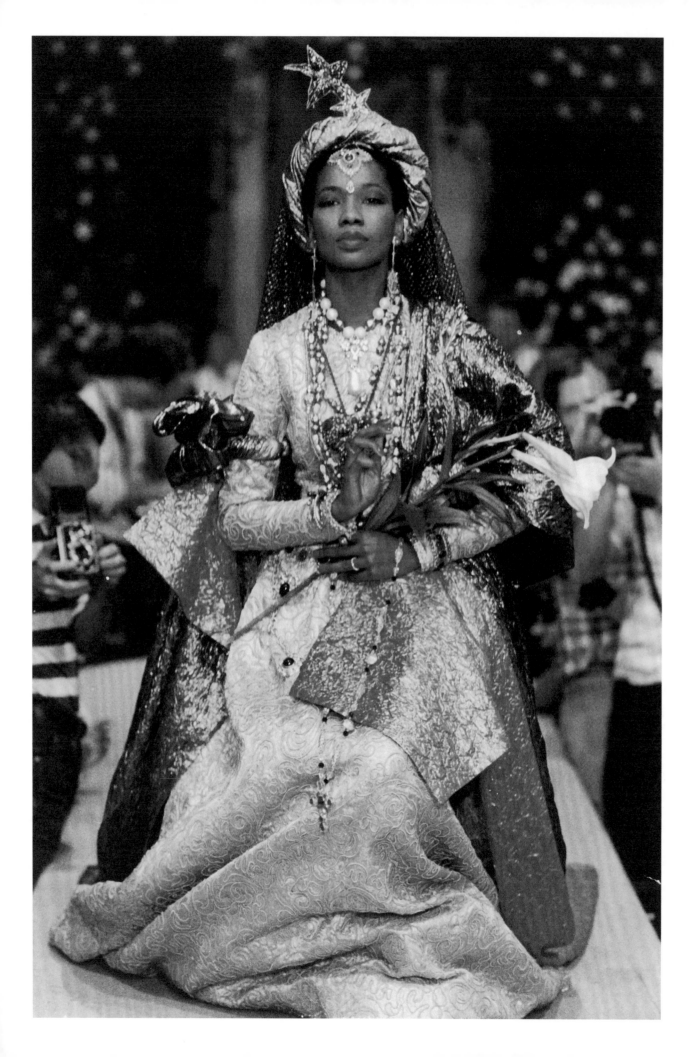

"I think of a woman as an object of worship . . . not only in the sacred sense of the word but also as an idol to be adorned with gold, like the statues of the Virgin Mary that the conquistadores adorned with their spoils, covering them in gold and offerings."

Yves Saint Laurent, 1977

Wedding dress titled "Shakespeare" worn by Mounia Orosemane, fall/winter 1980 haute couture collection. Photograph by François-Marie Banier.

39

Golden Hair

Since antiquity, blond hair has been an inherent criterion for "absolute" beauty for some cultures. Like the divine Venus, or the "ideal" women painted by Botticelli and Titian in the sixteenth century, blond hair constitutes a theme in literature and the arts.

The association between blond hair and gold is found in the work of Yves Saint Laurent. In 1967, the couturier closed his fall/winter haute couture show with a wedding dress embellished with a golden brocade train and embroidered braids. Its beauty was elevated by a unique headdress, more blond than the hair of Tristan's Isolde, a long braid made of gold metal threads decorated with chains, trimmings, and mother-of-pearl.

J. L.

Braided headdress, fall/winter 1967 haute couture collection.

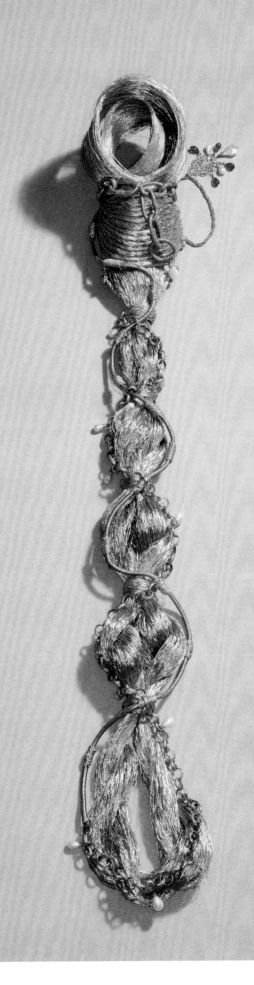

"Applied to women, this gold was never vulgar. It was a gold that illuminated women from within and made them shine."

Violeta Sanchez

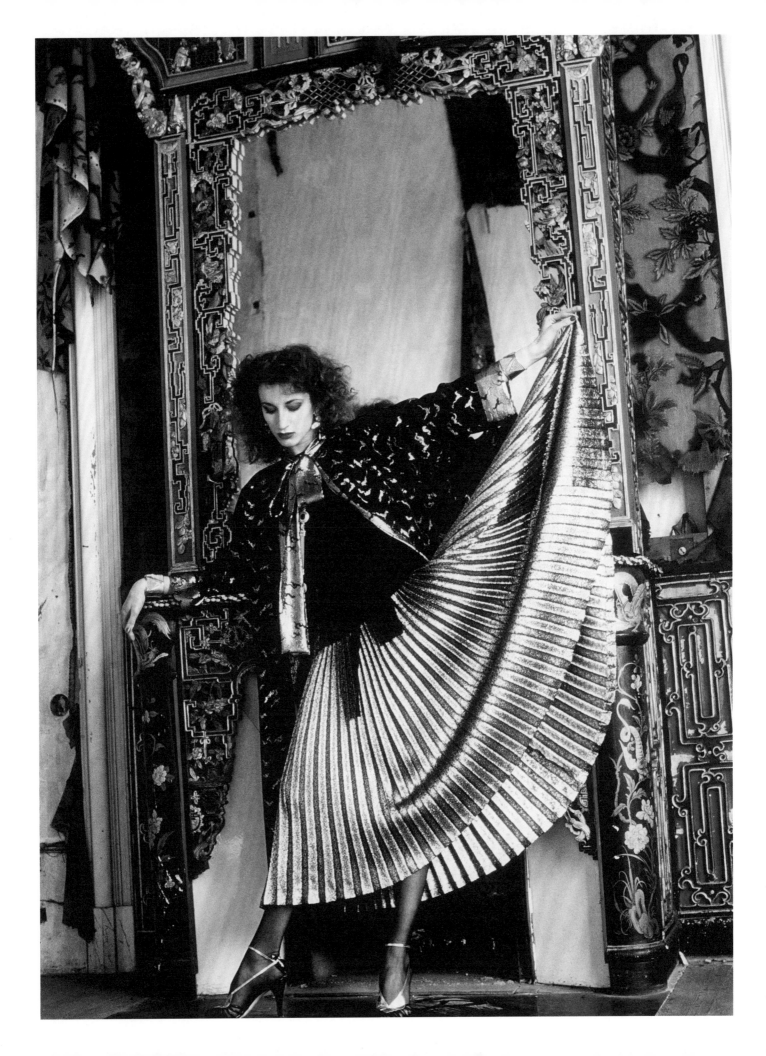

Loulou de La Falaise

Starting in 1972, Yves Saint Laurent found in Loulou de La Falaise an accomplice-interpreter of his whimsical taste. She worked alongside him until the closure of the couture house in 2002. "Accessories are the other way to dress in the style of Saint Laurent," she said. The so-called jewels *de fantaisie*, essential and ostensible accessories, punctuated the silhouette with golden touches to give the line of the garment the necessary shine in all circumstances. S. M.

Loulou de La Falaise wearing a brocade cape from the fall/winter 1988 haute couture collection. Photograph by Arthur Elgort, published in *Vogue* (Italia), December 1988.

"Dressed in Yves Saint Laurent, I felt like a powerful, elegant, and radiant woman."

Marisa Berenson

Lamé brocade ensemble worn by Micheline Van de Velde, fall/winter 1989 haute couture collection. Photograph by Guy Marineau.

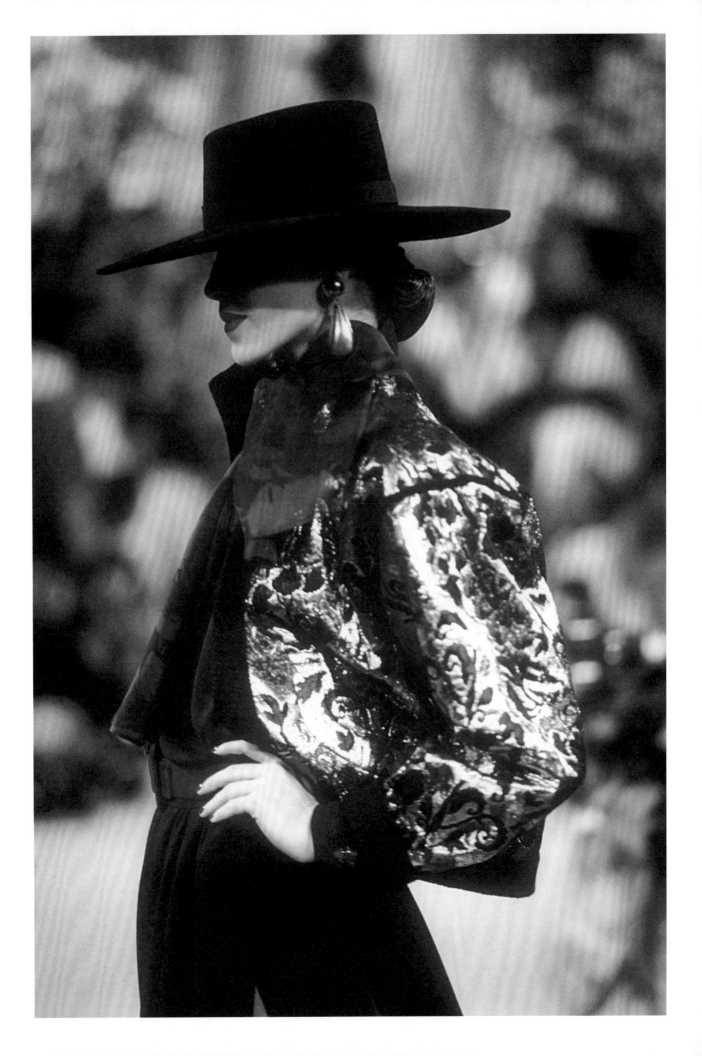

"Pierre Bergé and Yves Saint Laurent used to visit us separately. Yves Saint Laurent admired the taste of collectors such as the Rothschilds or the de Noailles. In addition to their respective acquisitions, Pierre Bergé had the tradition of choosing, each year, a bronze lion for Yves's birthday, as this was his astrological sign."

Alexis Kugel

Collection of objects dating from the seventeenth century, Kugel Gallery collection, Paris. The lidded coupe depicting a rearing horse in gilded silver is from the Pierre Bergé–Yves Saint Laurent collection.

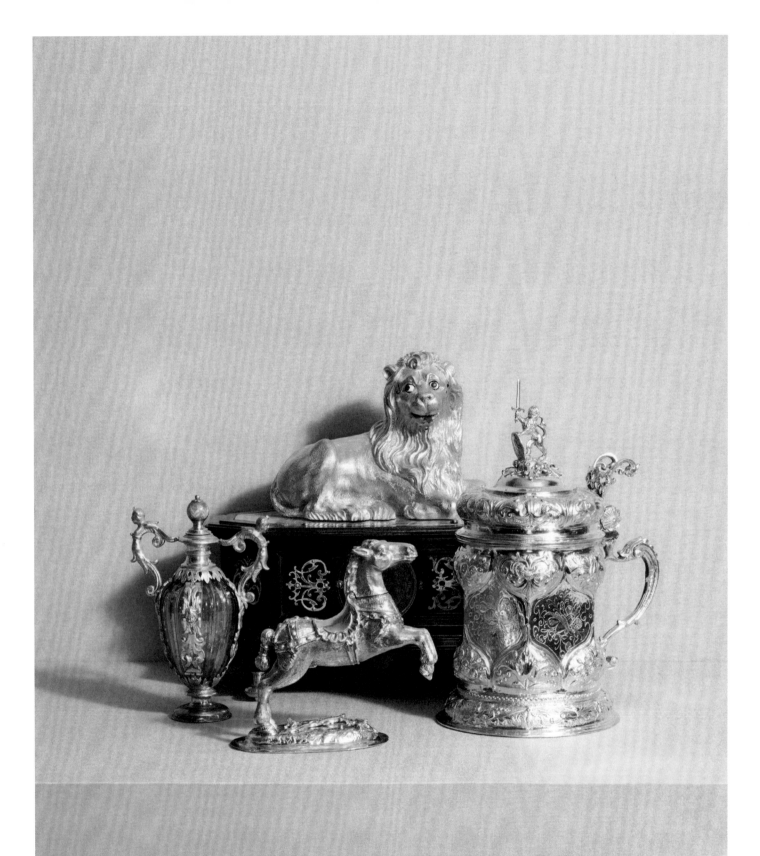

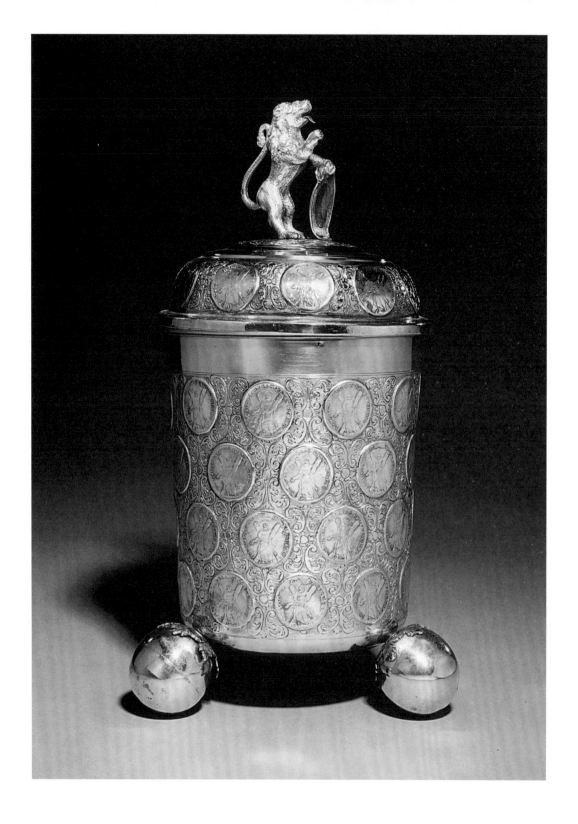

Cup and lid in vermeil, Leipzig, master goldsmith F.C., c. 1711, from the Pierre Bergé–Yves Saint Laurent collection.

Ensemble, spring/summer 1993 SAINT LAURENT *rive gauche* collection.

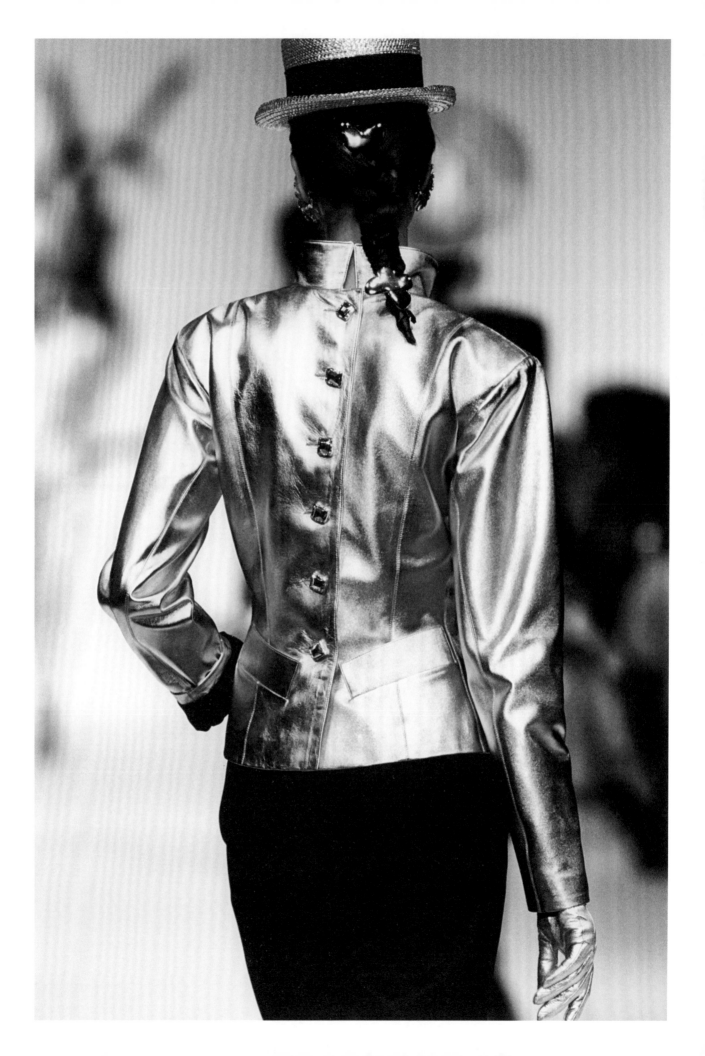

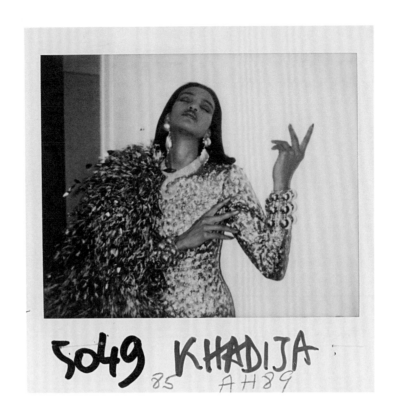

5049 KHADIJA
85 AH89

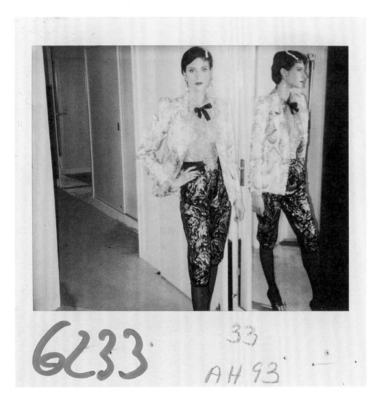

6233 33
 AH93

Evening ensemble worn by Khadija Adam Ismail,
fall/winter 1989 haute couture collection.

Ensemble worn by Ewa Meissner,
fall/winter 1993 haute couture collection.

Evening ensemble worn by Khadija Adam Ismail,
fall/winter 1989 haute couture collection. Photograph by Claus Ohm.

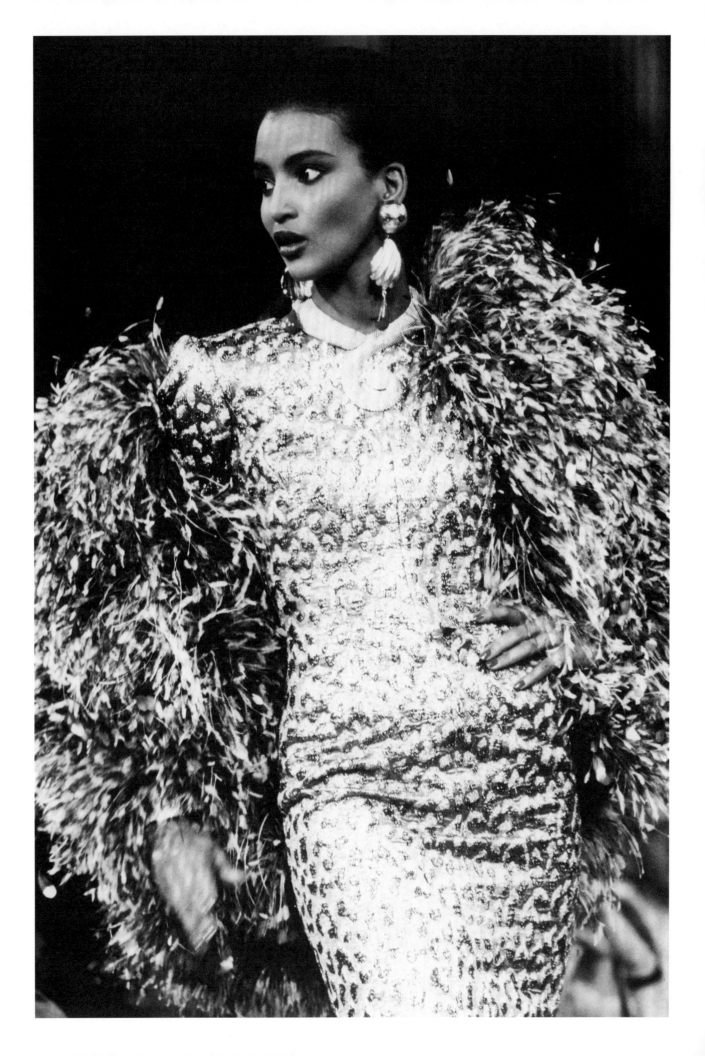

Gold Embroidery

This cardigan evokes the iconic suit jacket designed in the 1950s by Mademoiselle Chanel and inspired by Austrian men's jackets. Mademoiselle saw Yves Saint Laurent as a worthy successor, and *Life* magazine described him in 1962 as "the best couturier since Chanel."

This indispensable piece of a woman's wardrobe—with its straight, structured cut closed edge to edge—is a manifesto for freedom of movement. As for the motif of the rich embroidery, it recalls the interlacing of knitted stitches. By bringing together flexibility and practicality, Yves Saint Laurent offers lightness, fluidity, and ease. S. M.

Cardigan of an embroidered evening ensemble, fall/winter 1973 haute couture collection.

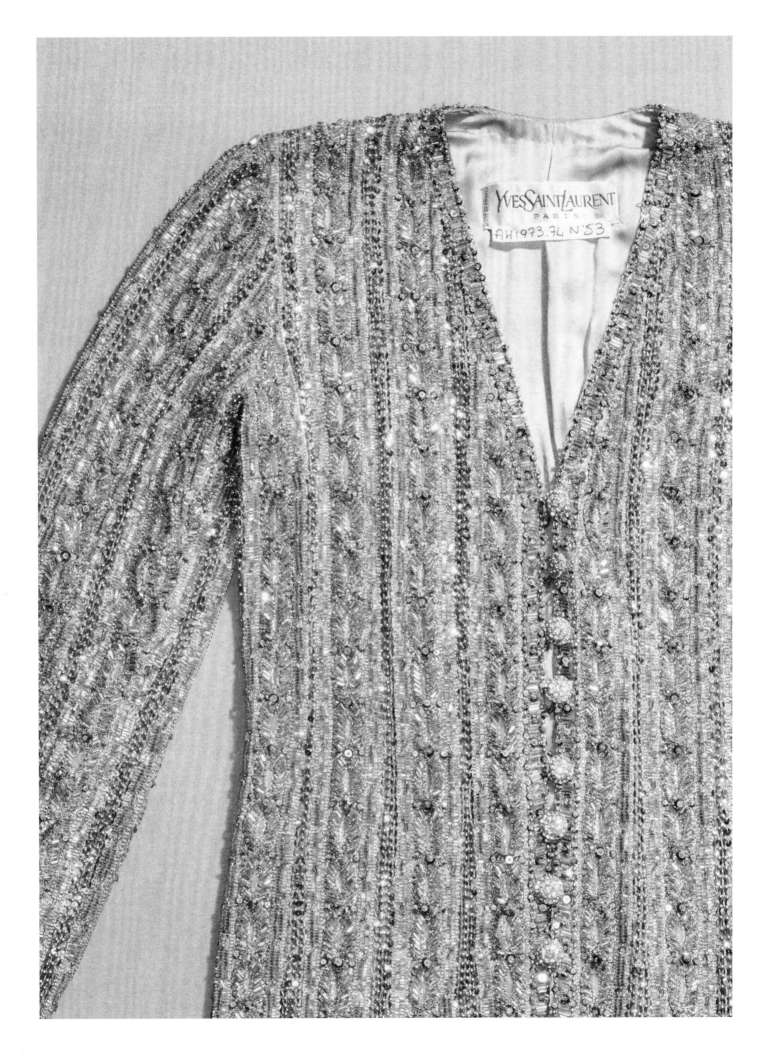

"I'm very discreet, not one to wear gold. I only like black, masculine things, dark suits with a cotton men's T-shirt. And yet, I had two sweaters, entirely of gold embroidery, which I fell in love with. They were works of art."

Betty Catroux

Betty Catroux wearing an evening ensemble. Photograph by Nadia Rein, published in *L'Art et la mode*, November 1973.

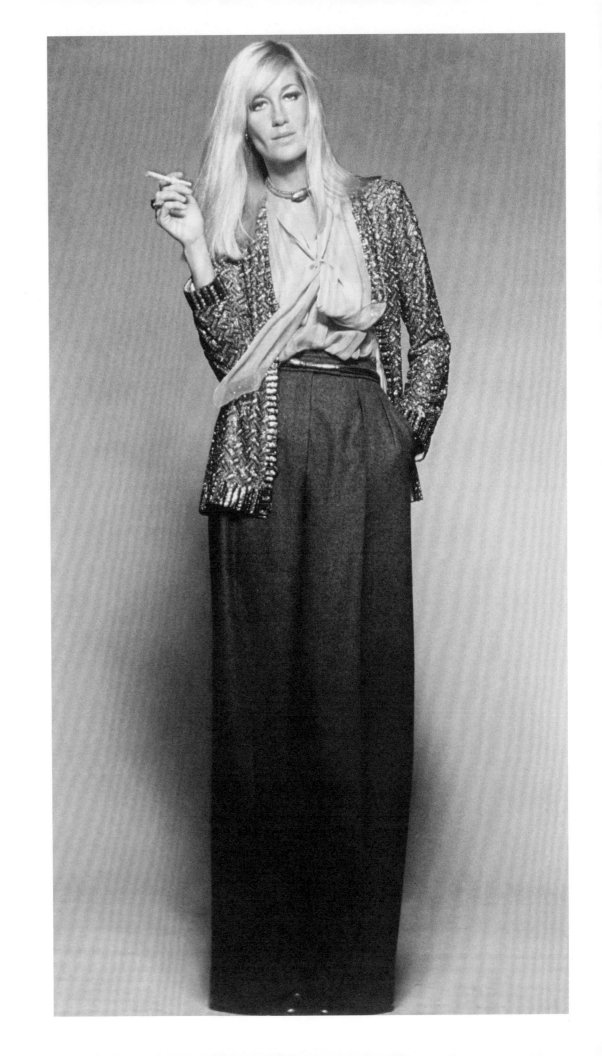

Series of research sketches, fall/winter 1975
SAINT LAURENT *rive gauche* collection.

"Yves Saint Laurent was the couturier of gold, a couturier of splendor, with a flamboyant Sun King side to him. There was a brilliance, a richness, jewels under the capes, incredible colors, an ambiance from the Arabian Nights. The fashion shows were theatrical but the clothes themselves were not. They were comfortable, and the women looked like queens. The folds of the gold fabric were like water flowing over the women."

Vincent Darré

Evening dress worn by Shalom Harlow, fall/winter 1994 haute couture collection. Photograph by Claus Ohm.

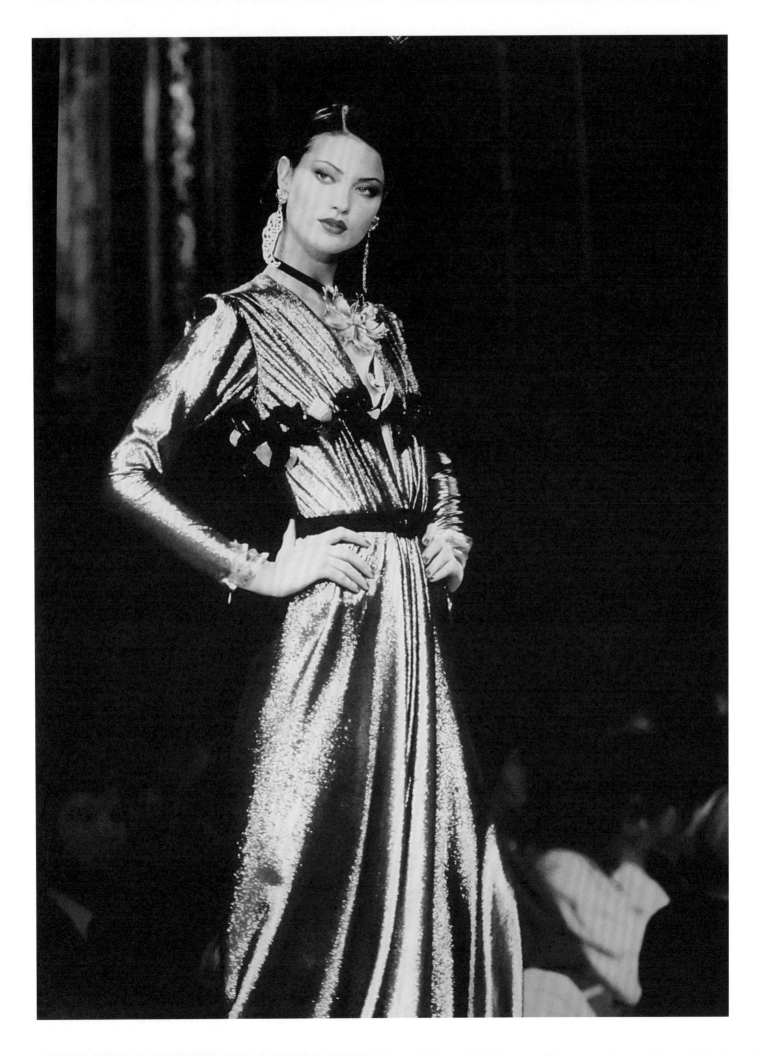

Robe
d'Or

Original sketch of an evening dress,
fall/winter 1991 SAINT LAURENT *rive gauche* collection.

Evening dress worn by Yasmeen Ghauri,
fall/winter 1991 SAINT LAURENT *rive gauche* collection.

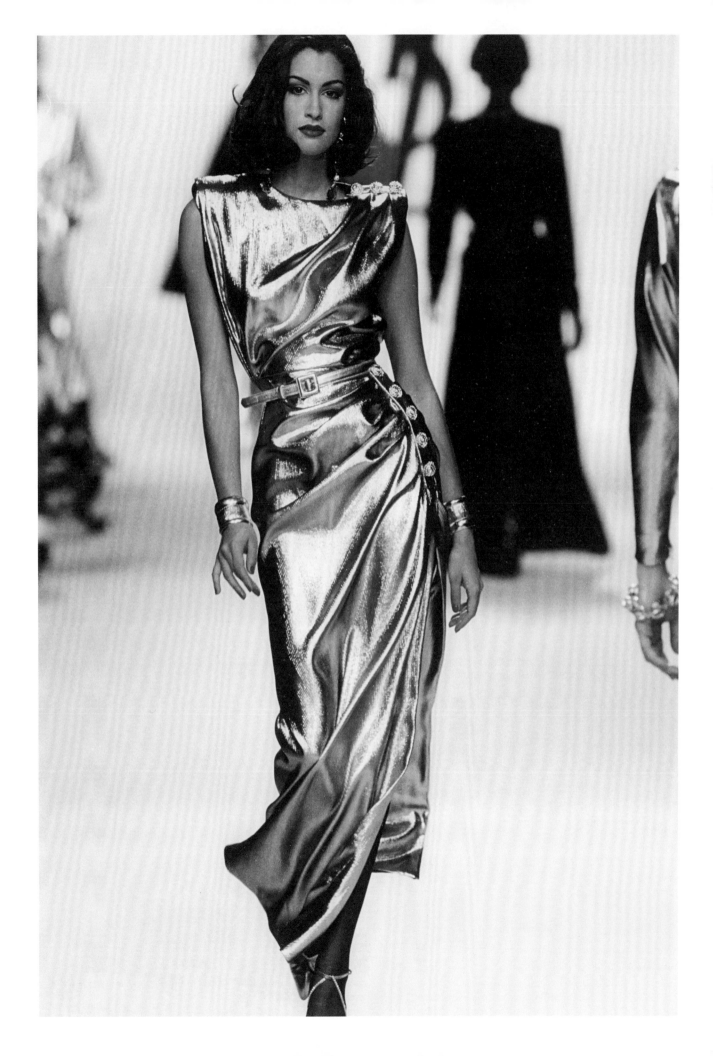

"For Yves Saint Laurent, gold was essential. It was both light and glamour."

Clara Saint

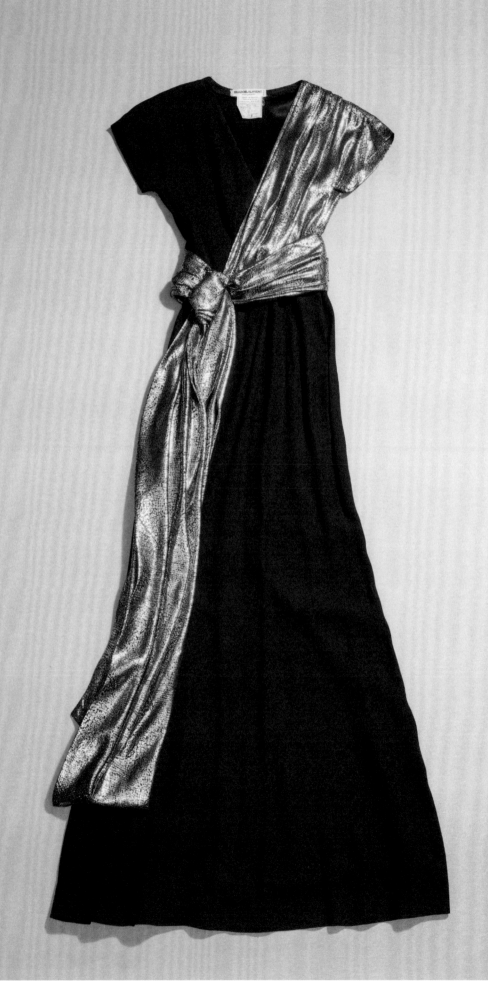

In Gold Letters

With this "poem-jacket," Yves Saint Laurent honored the most surrealist of designers, Elsa Schiaparelli. He shared her taste for fantasy, bold colors, casual humor, ornamental gold, and the dialogue between the arts, where literature and poetry hold an essential place.

In 1938, the Italian designer illuminated her mythical cape *Phoebus* ("Cosmique" collection) with solar rays embroidered in golden strips. Forty years later, Yves Saint Laurent had the word *Soleil* appear in full on a jacket in homage to Jean Cocteau.

The sun was evoked when Yves Saint Laurent had the name of Louis Aragon embroidered by Maison Lesage in gold metallic strips on the back of a short jacket. On the front were the words *Les Yeux d'Elsa* emphasized with large eyes. In his poem dedicated to his wife, Elsa Triolet, Aragon wrote: "Your eyes are so deep that leaning down to drink / I saw all suns mirrored in them."

S. M.

Original sketch of an ensemble "Hommage à Louis Aragon," fall/winter 1980 haute couture collection.

Following spread :
Jacket "Hommage à Louis Aragon" embroidered with the title of the collection, *Les Yeux d'Elsa* (1942), back and front side, fall/winter 1980 haute couture collection.

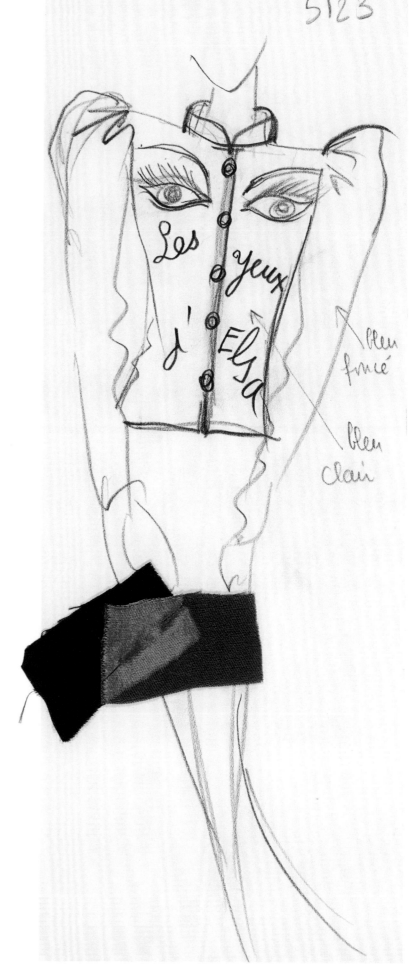

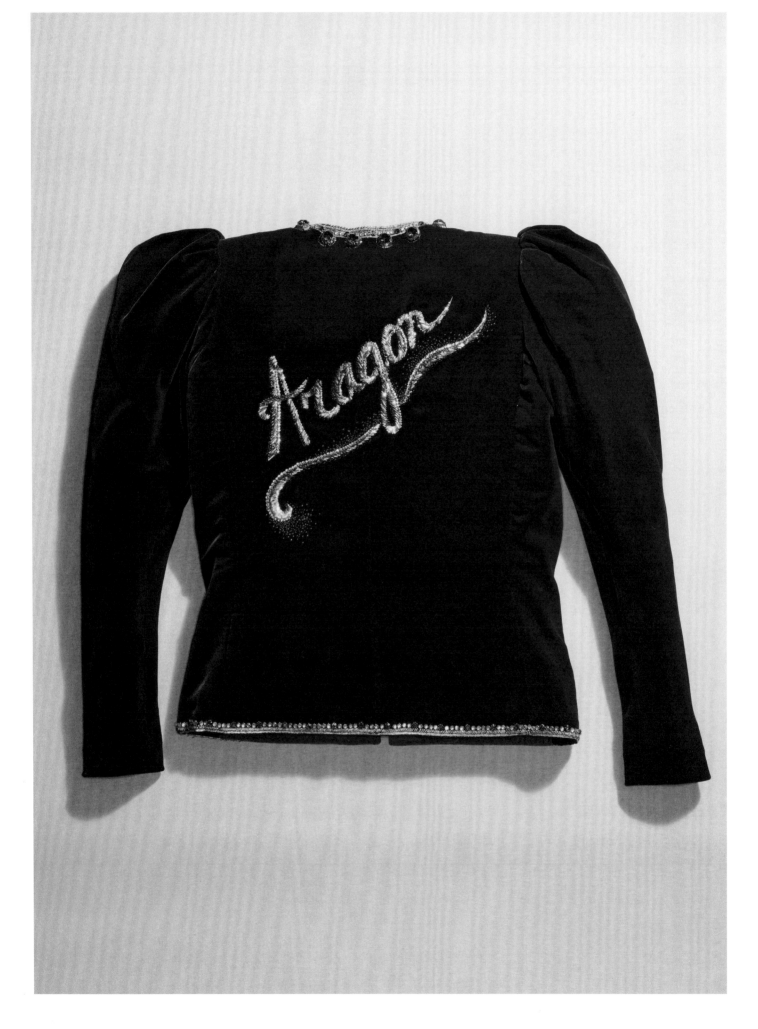

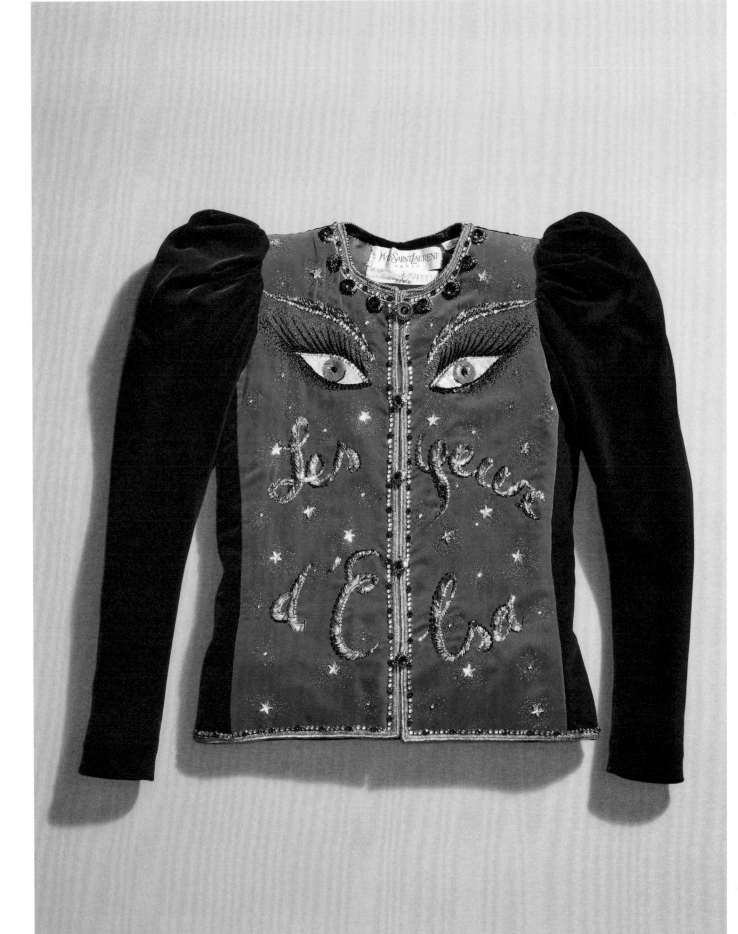

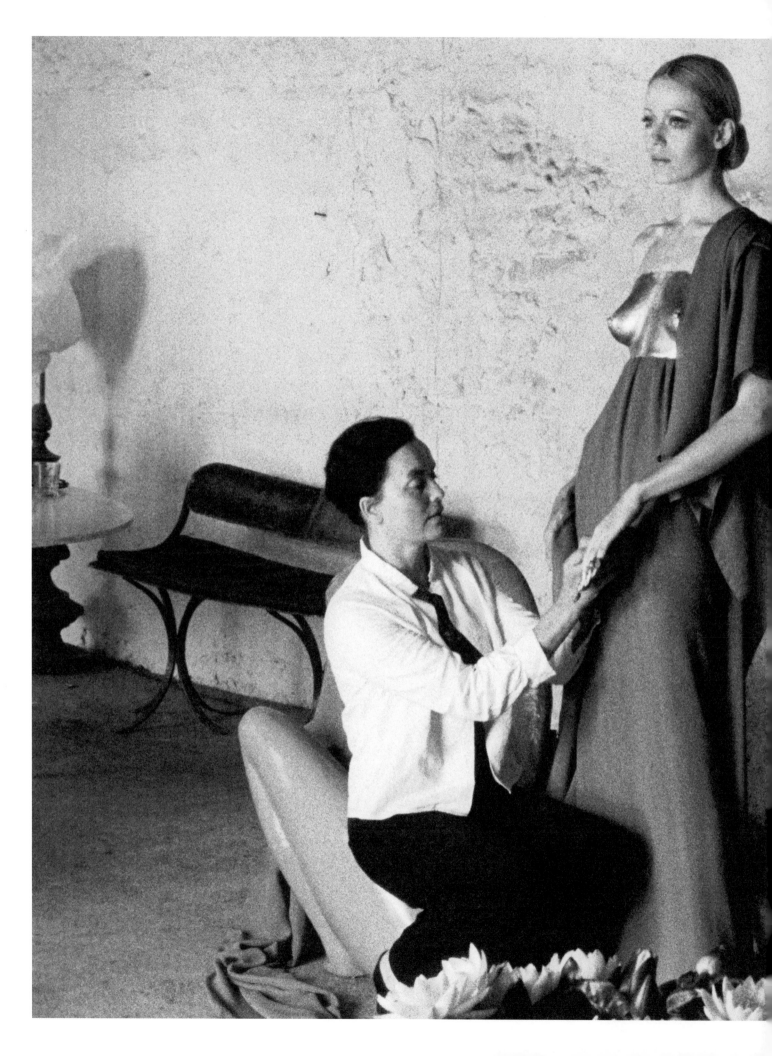

Claude Lalanne

Yves Saint Laurent and Pierre Bergé were seduced by the playful Baroque sculptures with flora and fauna themes by sculptors Claude and François-Xavier Lalanne. In 1965, they commissioned a bar for their home from the artists.

For the fall/winter 1969 haute couture collection, Yves Saint Laurent asked Claude Lalanne to make body casts of the bust and waist of one of his models. These casts, which would sheathe the skin in gold, were created to be worn with two dresses of light chiffon, one in blue and the other in black.

The relationship between the couturier and the sculptor was long-lasting: "For me, she created jewelry and sculptures that I wrapped around my models. In my homes, there were always works by Claude. In Paris was a salon of mirrors, an echo of Nymphenburg Palace. In Deauville, there were chairs of large pale blue leaves for conversation in an open-air tea salon, and candelabras with swirls of branches. In Marrakech, there was flora-inspired cutlery. What touches me about her is that she is able to combine the same exacting standards of craftsmanship and poetry. Her beautiful sculptor's hands seem to part the mists of mystery to reach the shores of art." S. M.

Previous spread:
Claude Lalanne and Yves Saint Laurent with models Lisa and Dominique Pommier during design creations for the fall/winter 1969 haute couture collection, house of the Lalannes, Ury, August 1969. Photograph by Jean-Philippe Lalanne.

Opposite:
Casts of neck and breasts in galvanized copper, collaboration with Claude Lalanne, fall/winter 1969 haute couture collection.

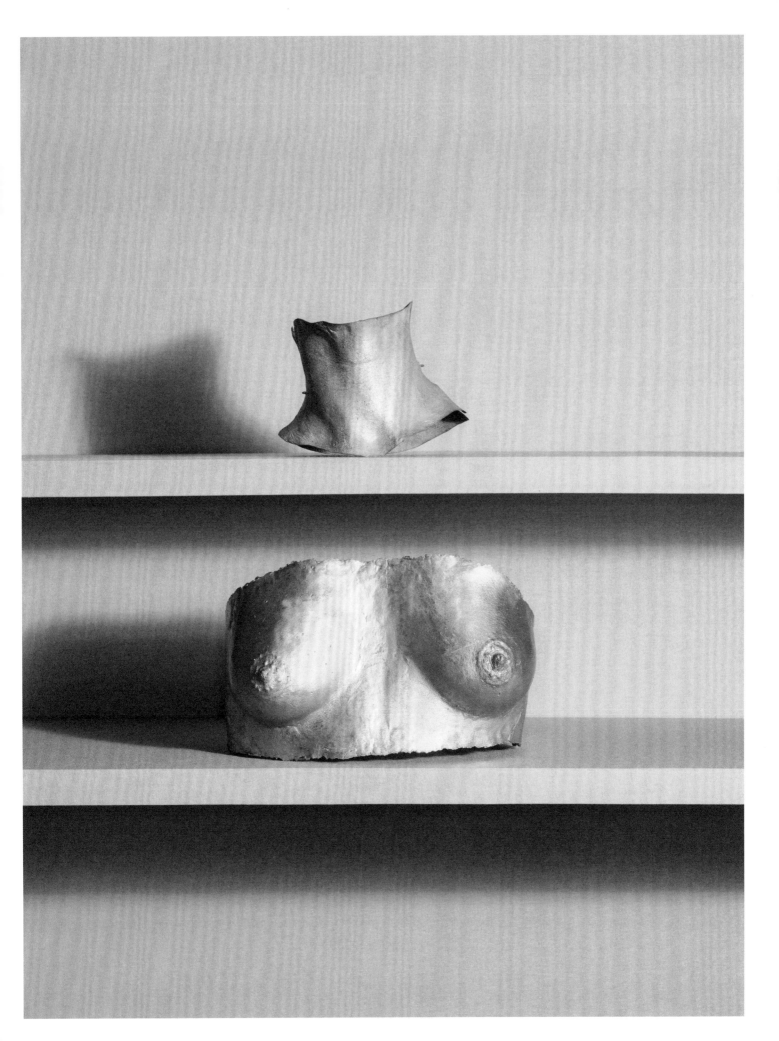

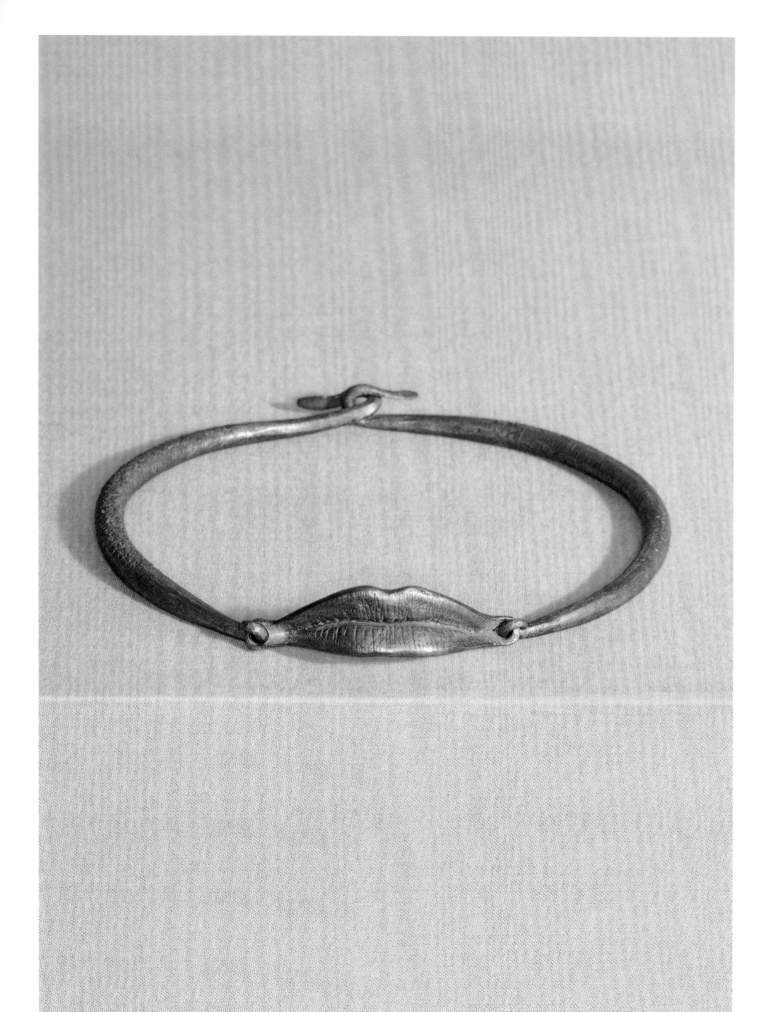

"Gold because its purity and flow molds to the body to create a single line."

Yves Saint Laurent

"Lips" torque in gilded bronze, collaboration with Claude Lalanne, fall/winter 1970 haute couture collection.

75

David Bailey

David Bailey photographed Yves Saint Laurent three times starting in 1970. This first unpublished black-and-white series depicts an Yves Saint Laurent who seems serene in his long hair, satin jacket, striped T-shirt, wristwatch, and signature glasses. Around his neck he wore the golden torque created by Claude Lalanne and molded from Yves Saint Laurent's own lips. The other two portraits were published in 1972 alongside Anjelica Huston *Vogue* (Great Britain) and in 1983 (*Harper's Bazaar*, United States).

Married to Catherine Deneuve at the time, David Bailey introduced Yves Saint Laurent to the young actress. This was the beginning of a long friendship. S. M.

Yves Saint Laurent wearing a necklace created in collaboration with Claude Lalanne, 1970. Photograph by David Bailey.

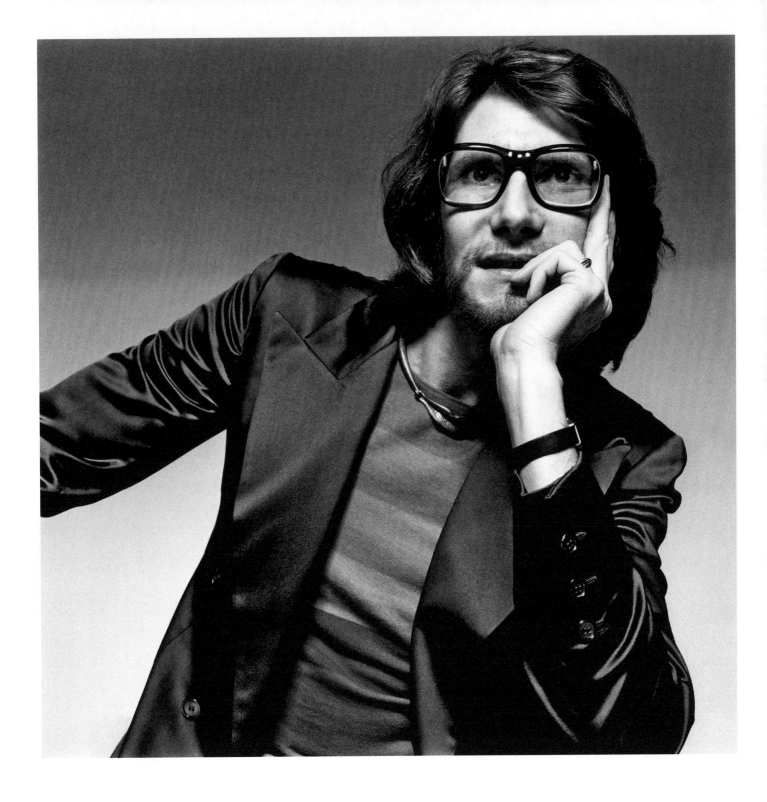

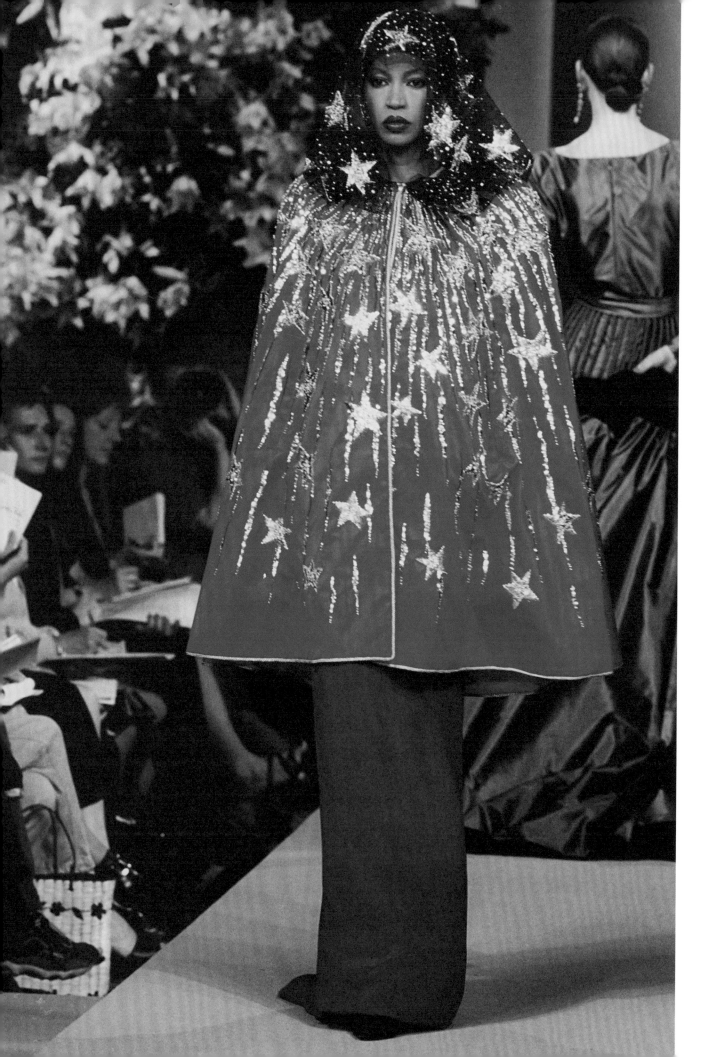

Yves Saint Laurent

MAGICIAN

Evening ensemble worn by Amalia Vairelli,
fall/winter 2000 haute couture collection.
Photograph by Frédéric Bukajlo.

A thick wool pea coat with pockets was the very first garment of Yves Saint Laurent's very first haute couture show. This same garment also opened his farewell fashion show. The coat was a masculine garment redesigned for a woman to offer her comfort, practicality, and confidence. "Power was held by men, and by dressing women in their clothes, you gave women power,"[1] explains Pierre Bergé. But the gender of clothing was not everything. On his jacket, the couturier arranged gold buttons. "I love gold, it's a magical color,"[2] he said. Prodigious, even, for those who know how to manipulate it. Gold is the color of kings, crowns, and scepters, the fleur-de-lis on coats of arms, and even the capes in which sovereigns wrap themselves. Balthazar's gift to Jesus declared it as such: "Behold gold, he is a king."[3] Yves Saint Laurent knew all this. The creator stole these insignias from kings to pass them on to women; the couturier had the gift of filling women's wardrobes with clothes of power. It was no coincidence that, in this first haute couture collection for spring/summer 1962, black dominated. Yves Saint Laurent was a paradox: discreet and charismatic, simple and Baroque, serious and facetious, resolutely modern and deeply nostalgic. He was a personality full of oxymorons that made him choose and adapt this verse by Jean Cocteau to embroider on a jacket for the fall/winter 1980 collection, which was a tribute to his favorite poets: "Sun, I am black inside and Rose."[4] To observe the gold in his work was also to follow the evolution of black—a fittingly modern black, never sad or of grief and conventions, but a deep, shiny, masterful black; the black that dressed the prominent court of Burgundy. "I always illuminate it with gold,"[5] said Yves Saint Laurent. One does not go without the other. Using extensive embroideries or strips of gold paper and by imposing jewels or buttons, the couturier defined these dynamic silhouettes.

Toward the end of his career, Yves Saint Laurent described himself as an "old magician."[6] It was a story straight out of a fairy tale, in which shears and a golden thimble were capable of miracles. His secretiveness reinforced this impression. A bit of an indissoluble mystery surrounded him. The couturier was a discreet man. In front of journalists, he was charming with his soft voice and his gentle way of phrasing, but he revealed little of himself. His silent moments reinforced this charisma. Yves Saint Laurent also knew how to please, to charm, to enchant. His powers were imagined as wonderful. "Yves' name is magic," said *Time* magazine one day in September 1968. The couturier was a bit of an alchemist. He transformed what he touched into gold and surrounded himself with talismans. Yves was superstitious, and a bit mystical—a few sprigs of lily of the valley in his pocket or buttonhole, inherited from Christian Dior, sheaves of wheat for luck, which he had everywhere: at home, in the studio, embroidered on a jacket, and transformed into a brooch by Robert Goossens. The couturier believed in magic, the one that saves us from everyday life. His imaginary adventures were like tales, paved with gold, populated by fantastic characters: "fabulous boyars, grandiose samurai, savage Mongols, all an epic consisting of golden brocades, faille, ottomans cut as if by scimitars, and stifling barbarian furs."[7]

1 Pierre Bergé, *Lettres à Yves*, Paris: Gallimard, 2010.
2 Quoted by Laurence Benaïm in *Yves Saint Laurent*, Paris: Grasset, 2018.
3 Saint Gregory the Great, *Homilies sur les évangiles*, Sainte-Madeleine, 2004.
4 "Moi je suis noir dedans et rose dehors, fais la métamorphose," extract from Jean Cocteau, "Batterie," *Œuvres poétiques complets*, Paris: Gallimard, coll. Bibliothèque de la Pléiade, 1999.
5 *Elle*, March 7, 1968.
6 *Yves Saint Laurent, de fil en aiguille*, documentary by David Teboul, 2003.
7 Excerpt from his book project by Éditions Grasset published in *Le Point*, July 1977.
8 Patrick Mauriès, *Yves Saint Laurent: la folie de l'accessoire*, London: Phaidon, 2017.
9 Interview with Marisa Berenson as part of this book, 2022.
10 Elsa Schiaparelli, *Empress of Paris Fashion*, foreword by Yves Saint Laurent, London: Aurum Press, 1986.
11 *Yves Saint Laurent, de fil en aiguille*, documentary by David Teboul, 2003.
12 Directed by Joseph L. Mankiewicz, 1963. Academy Award for Best Costume Design for Irene Sharaff and Vittorio Nino Novarese. In 2012, the gold cape was sold at auction for $59,365.
13 *À Zizi Jeanmaire*, November 21, 1977.
14 *Paris Match*, December 7, 2014.

The collections inspired by these distant lands, which existed only in the dreams of Yves Saint Laurent, were filled with clothes that made a statement, such as the gold damask evening jacket and its matching leather gloves. The haute couture collection titled "Opéra-Ballets russes" for fall/winter 1976, the one Saint Laurent admitted was his favorite, illustrates this enchantment, as did that of fall/winter 1977, titled "Les Chinoises," which followed the release of Opium perfume, for which Jerry Hall posed on an advertisement wearing a gold embroidered jacket and purple pants, the other color of magicians.

Yves Saint Laurent adorned his models more literally. "I think of a woman as an object of worship . . . not only in the sacred sense of the word but also as an idol to be adorned with gold, like the statues of the Virgin Mary that the conquistadores adorned with their spoils, covering them in gold and offerings."[8] He built them a golden armor in which they move, admirably, imperiously, and divinely. Some predicted the death of couture, to which Yves Saint Laurent responded with wonderous and dazzling silhouettes. To Marisa Berenson, Elsa Schiaparelli's granddaughter, the designer had said, "Your grandmother is a magician,"[9] creating a bond between them. "Schiap," daring and whimsical, was adept at trompe l'œil, of spectacle, of stars. As a child, Yves Saint Laurent dreamed of her creations: the big gold buttons of her velvet jackets, the embroidery of her most famous cape, *Phoebus*, with sequins and gold metallic threads on a shocking pink background for the winter 1939 collection with an evocative title, "Cosmique." In a foreword devoted to the work of the couturier, Yves Saint Laurent wrote that "she bewitched Paris" with her "'candy bags,' filled with nuggets of gold and flakes of silver."[10] The vocabulary of the fields of magic and gold are omnipresent. Schiaparelli worked with Christian Bérard, whose talent as a costume designer and decorator Yves Saint Laurent admired. The couturier explained the influence of theater and cinema on his creations: "My evening dresses always evoke a dramatic or romantic œuvre."[11] The couturier had the look of Marlene Dietrich imprinted in his mind, the perfect combination of the androgynous and fatal woman. He admired the abundance of gold on Liz Taylor's costume as queen of Egypt in *Cleopatra*[12]: a 24-carat gold cape topped with a headdress reminiscent of the feathers of a phoenix, which owed much more to dreams than to historical reality. In 1990, a flowing and light gold lamé silk, created by Maison Brochier in Lyon, led him to imagine a captivating dress, a tribute to Marilyn Monroe, the other archetype of the Hollywood dream. "A magic of light and shadow! That of the theater!"[13] Yves Saint Laurent said. The couturier also created for fiction. Like Bérard before him, in 1978, he designed the costumes for *L'Aigle à deux têtes*, a play by Jean Cocteau. He created the costumes of Zizi Jeanmaire, star of the music hall, and the incredible combinations of Johnny Hallyday and Sylvie Vartan, of which he pinned a photo on the corkboard in his office. Onstage, whether for an evening or for a day, Yves Saint Laurent used his powers to enchant the world of women, and the world in general, using the artifices at his disposal to make nobler everything that helped to overcome the night. Much later, Marisa Berenson returned the compliment: "Yves, he was a magical man."[14]

Yvane Jacob

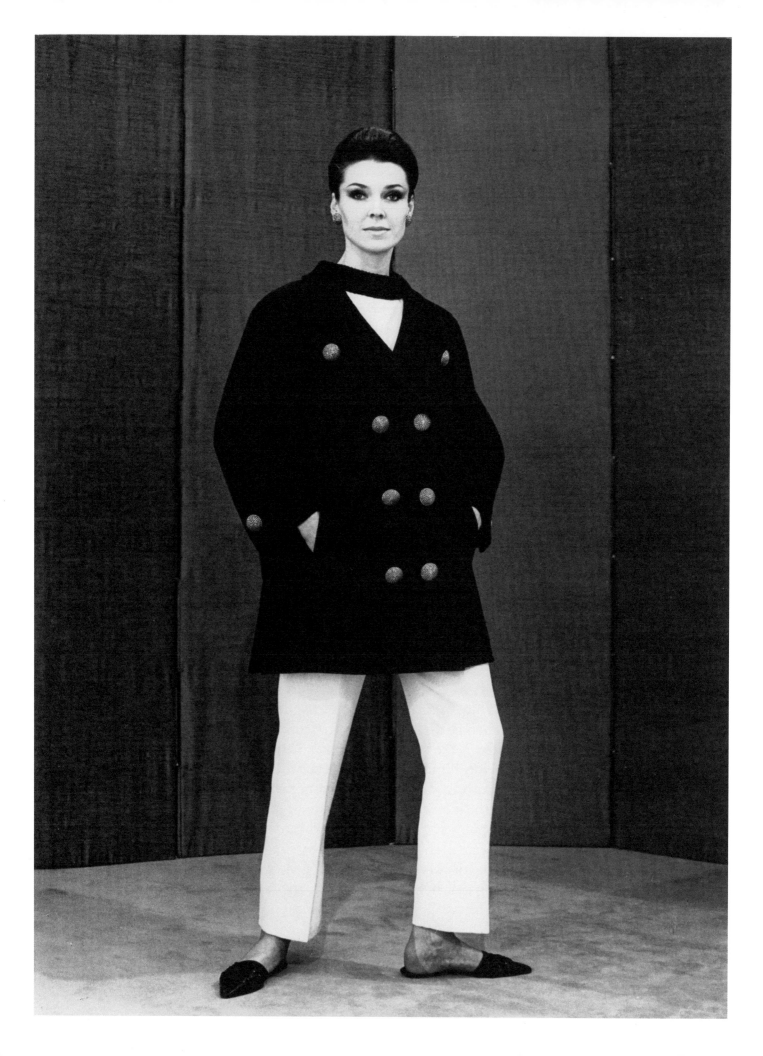

"I love gold buttons. I think these are a woman's day jewelry … I put a lot of gold buttons on black coats or navy blue coats."

Yves Saint Laurent, 1968

Ensemble called *premier caban* worn by Heather Jeffery, spring/summer 1962
haute couture collection. Photograph by Jacques Verroust.

Day Jewelry

A necessary and useful element, the button became an ornament that punctuated and accentuated certain lines of his designs. Yves Saint Laurent declared in a 1968 television interview: "It shines, it looks cheerful, it serves a purpose, it is a great raison d'être, and it prevents putting jewelry on during the day. I don't like jewelry so much during the day." Thanks to these buttons, a woman could maintain a certain distinction during the day and save her adornments for the evening.

In 1966, for the fall/winter haute couture collection, smaller golden touches appeared, such as the use of studs. Discreet yet numerous, they became the symbol of a more beatnik fashion, closer to street fashion. The imposing golden buttons gave way to youth and modernity, echoing the launch of the ready-to-wear line SAINT LAURENT *rive gauche* that same year. D.É.

Jacket, fall/winter 1966 haute couture collection.

Following spread:
Collection of gold buttons from the Yves Saint Laurent studio.

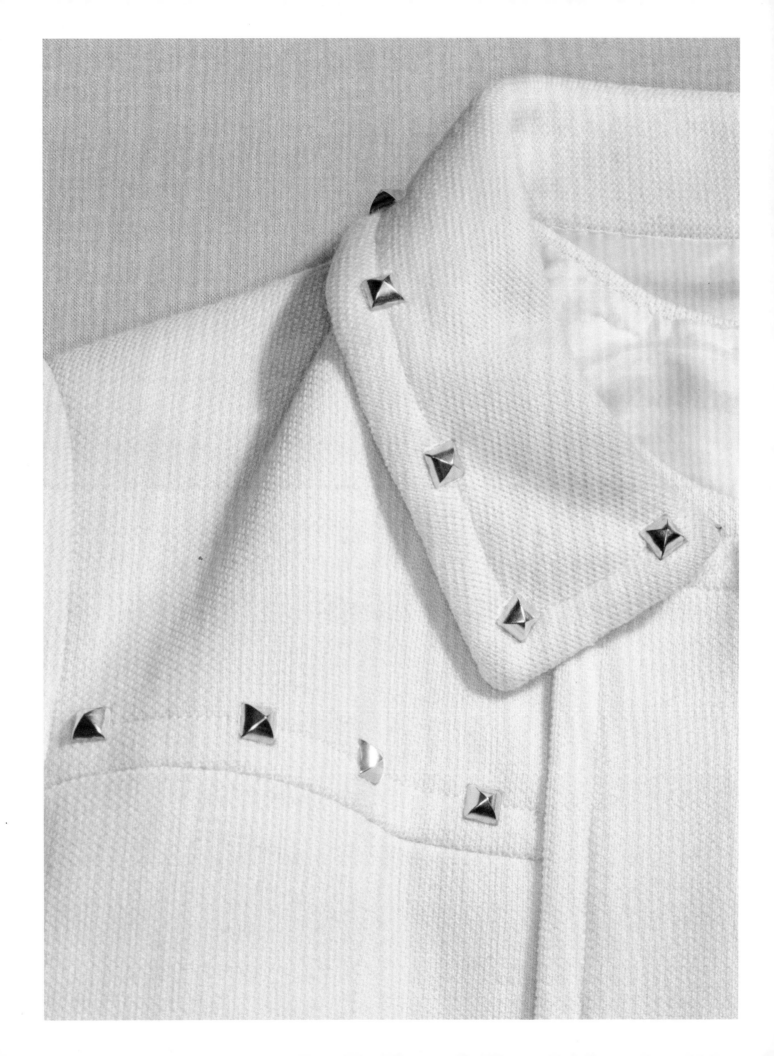

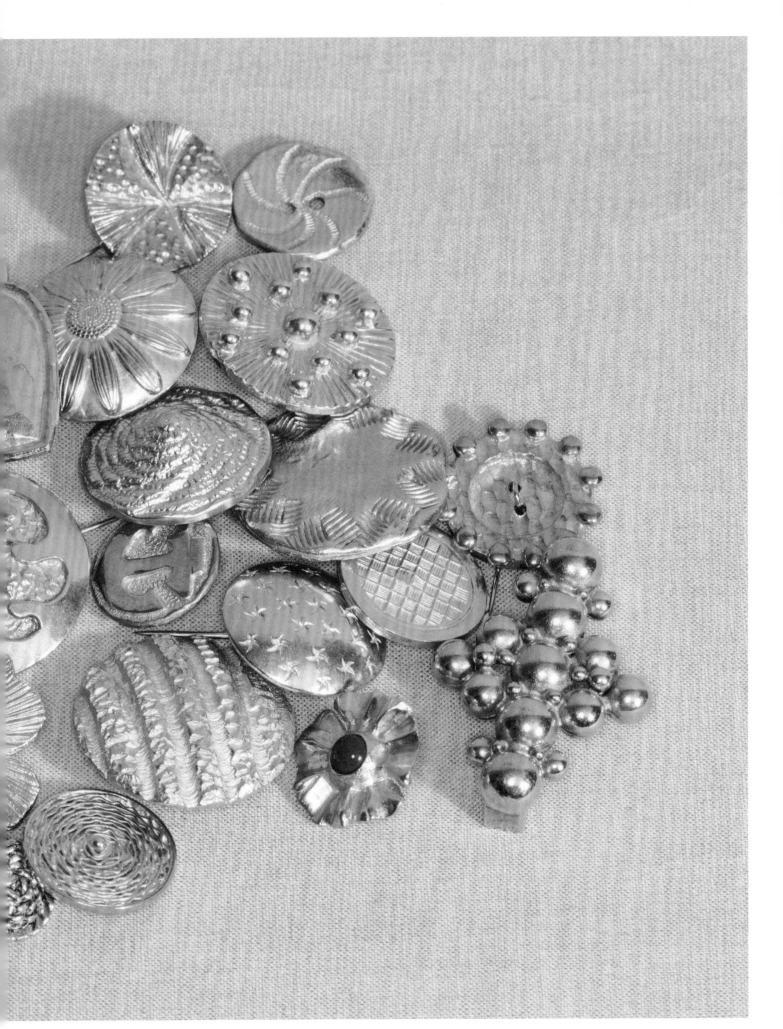

Gold Fabrics

The fabrics used by Yves Saint Laurent attest to the designer's expert eye and taste for materials, especially brocade. A common and commercial term with no real technical meaning, brocade refers to fabrics shaped with complex weave made from damask—that is to say, richly decorated fabrics whose effects are often emphasized and enhanced by gold and silver. This material was very popular with the couturier, who used it in abundance, especially in his fall/winter 1989 haute couture collection.

 J. L.

Brocade ensemble worn by Katoucha Niane,
fall/winter 1991 SAINT LAURENT *rive gauche* collection.

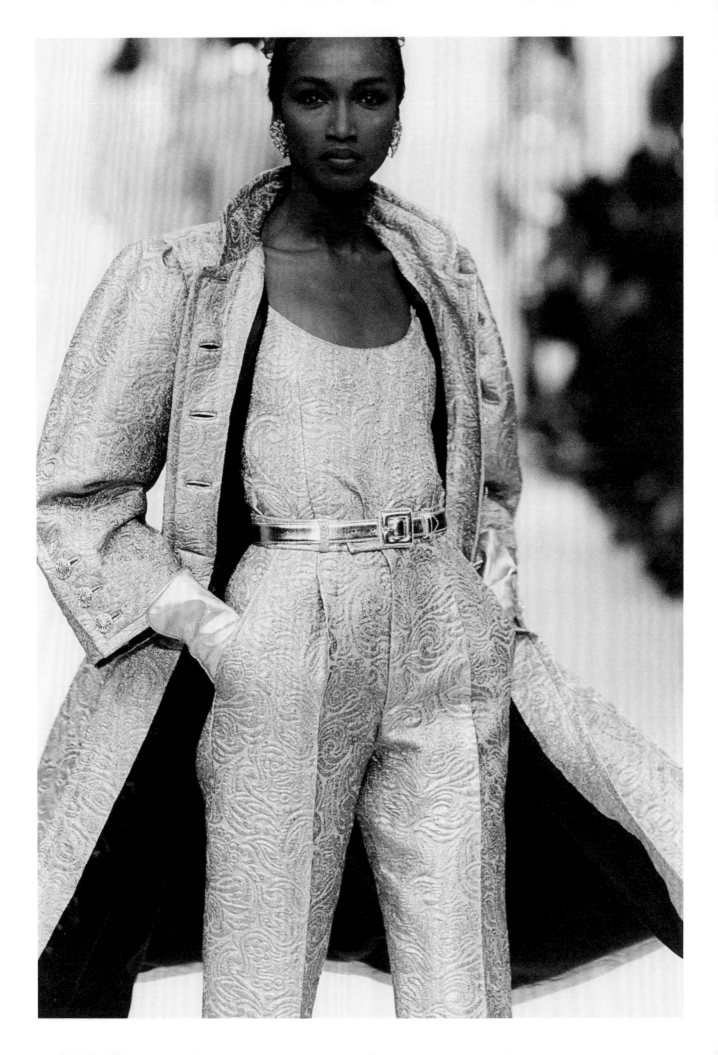

"All his works of art were necessary tools to provide a sense of joy to which one could cling to avoid sinking into the dramas of life. He had this same desire to adorn a woman with something to help her escape herself and her worries. The value of gold did not matter as much to him as the idea of it. Its monetary value did not count as much. He only wanted to give women the opportunity to dazzle, to amaze, to illuminate."

François-Marie Banier

Embroidered lace sheath dress worn by Magali Lemoine, spring/summer 1994 haute couture collection. Photograph by Guy Marineau.

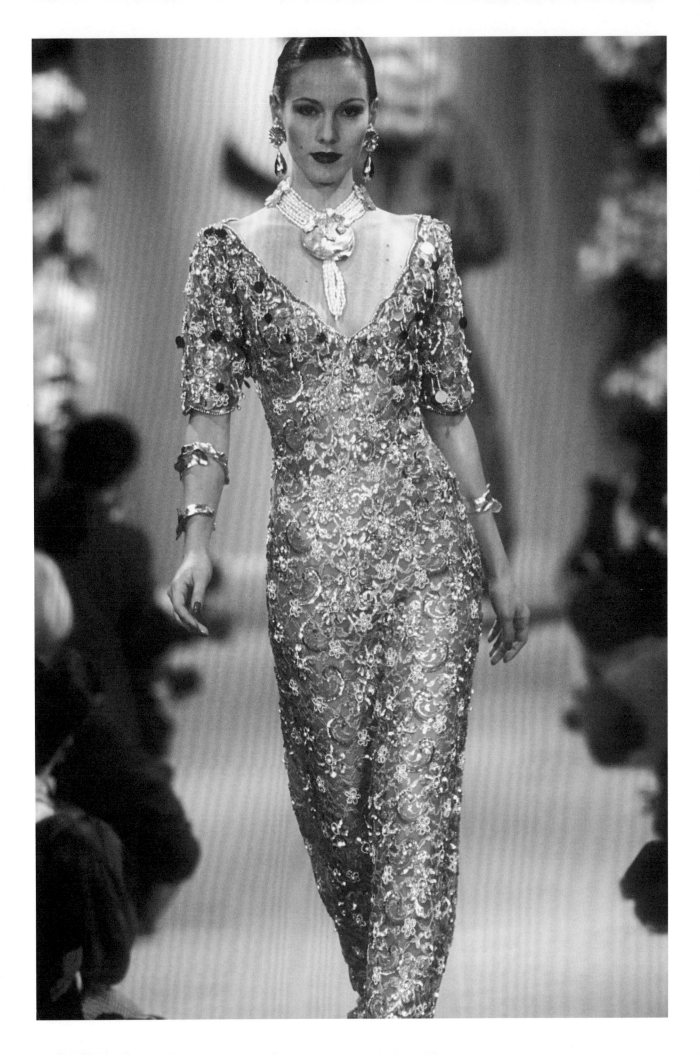

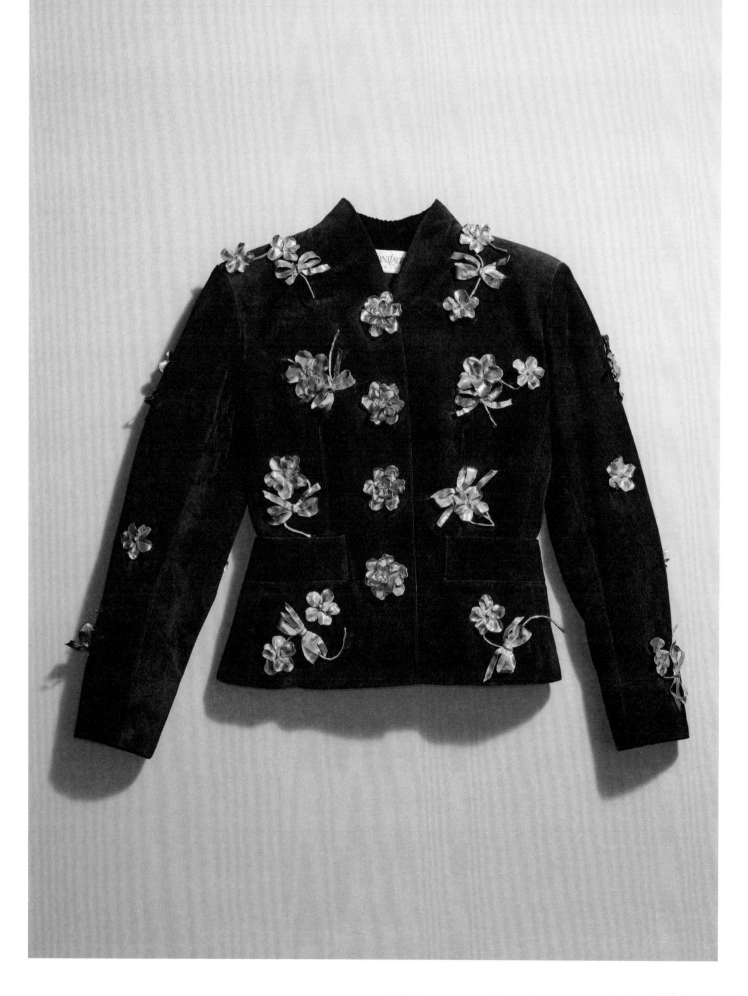

"I always enliven black with gold, through buttons, belts, and chains."

Yves Saint Laurent, 1968

Jacket from a cocktail ensemble,
fall/winter 1988 haute couture collection.

93

Boutons

gardéniaor

gardenia
a coeur de
perle +
rubis et
emeraude

perle grise
perle blanche
ou
contraire
ou

Tout
Blanc
(perles

et Boucles
d'oreilles

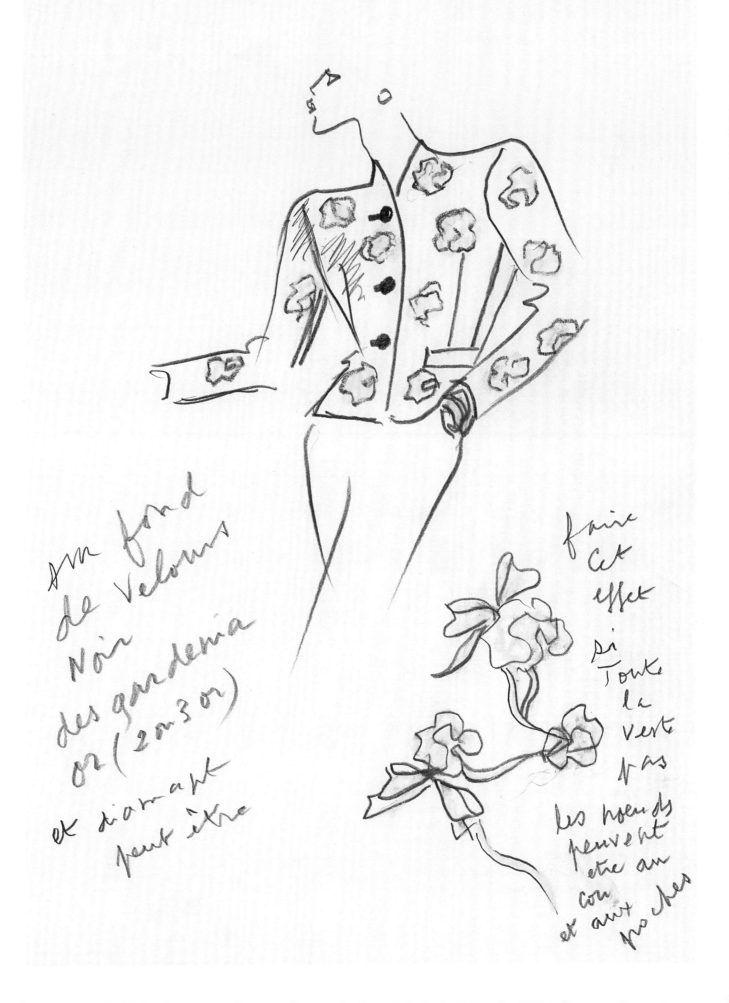

Gold Hands

Haute couture cannot exist without artisans. Among these artists, embroiderers hold an essential place. Yves Saint Laurent surrounded himself with the greatest artisan houses, such as Pierre Mesrine, Vermont, Hurel, and of course Maison Lesage. Monsieur François Lesage (1929–2011) was one of the few "suppliers" to enter the studio, the den of creation.

Embroidery is light, pattern, and relief. It meets all technical challenges and reveals all materials, from the noblest (gold leaf) to the simplest (plastic film). S. M.

Evening ensemble worn by Karen Mulder,
fall/winter 1995 haute couture collection. Photograph by Guy Marineau.

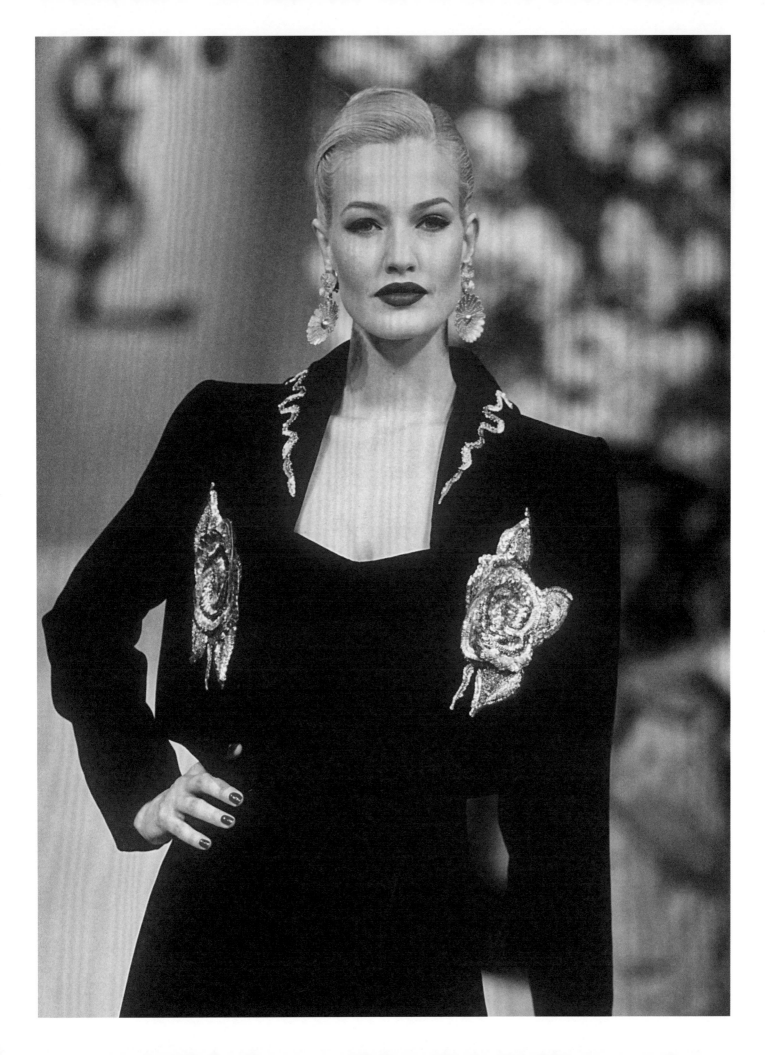

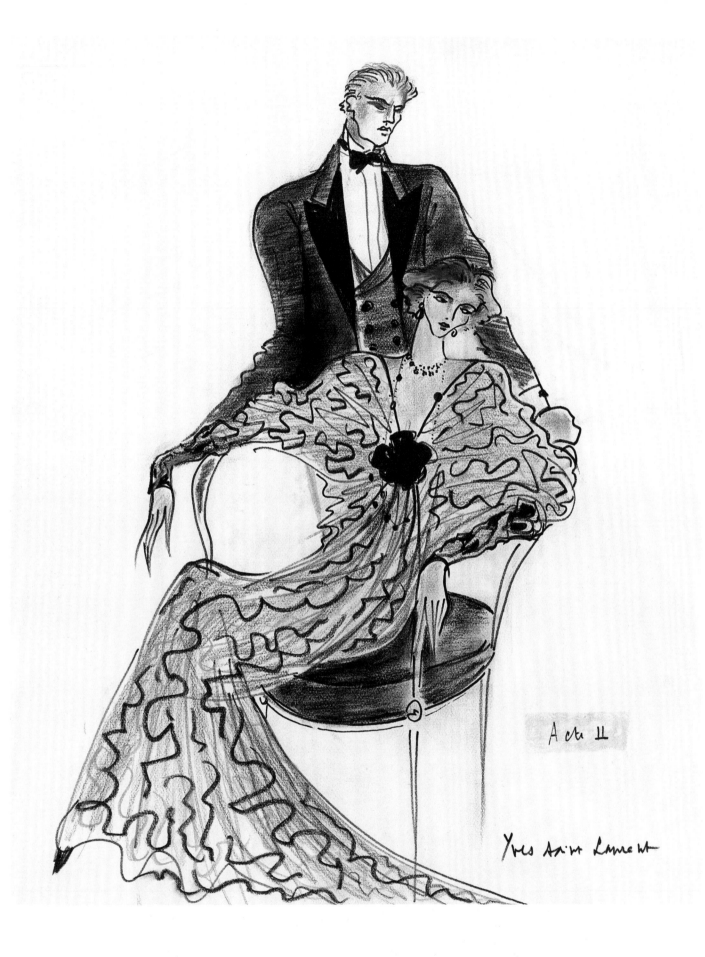

Acte II

Yves Saint Laurent

"There was the Athénée, Jouvet, Bérard. The first favorites. There was the spark of this magical and unique pair of swans, which, from the bottom of a Bavarian lake, Cocteau had brought forth to transform into golden eagles and reach the highest peaks … That's why I chose, without a moment's hesitation, to decorate and dress *Cher Menteur*."

Yves Saint Laurent, 1980

Sketch of costumes for Edwige Feuillère as Mrs. Patrick Campbell and Jean Marais as George Bernard Shaw in Act I of the play *Cher Menteur* by Jean Cocteau, directed by Jérôme Kilty at the Athénée Théâtre Louis-Jouvet, Paris, 1980.

"Gold was sacred. Yves Saint Laurent loved ritual. He was always surrounded by sheaves of wheat, a symbol of gold. He loved the decorations in Baroque and Orthodox churches, golden crosses, and richly dressed Madonnas. At the same time, gold was also, for him, that of Hollywood glamour. He mixed the two, the festive and the sacred."

Françoise Picoli

Previous spread:
Collection of awards and objects: Golden Thimble of European Fashion award, received in 1993, and Golden Shears received in 1994, preserved at Yves Saint Laurent's studio; Crown, spring/summer 1995 haute couture collection.

Opposite:
Sheaf of wheat offered to a colleague of Yves Saint Laurent, private collection.

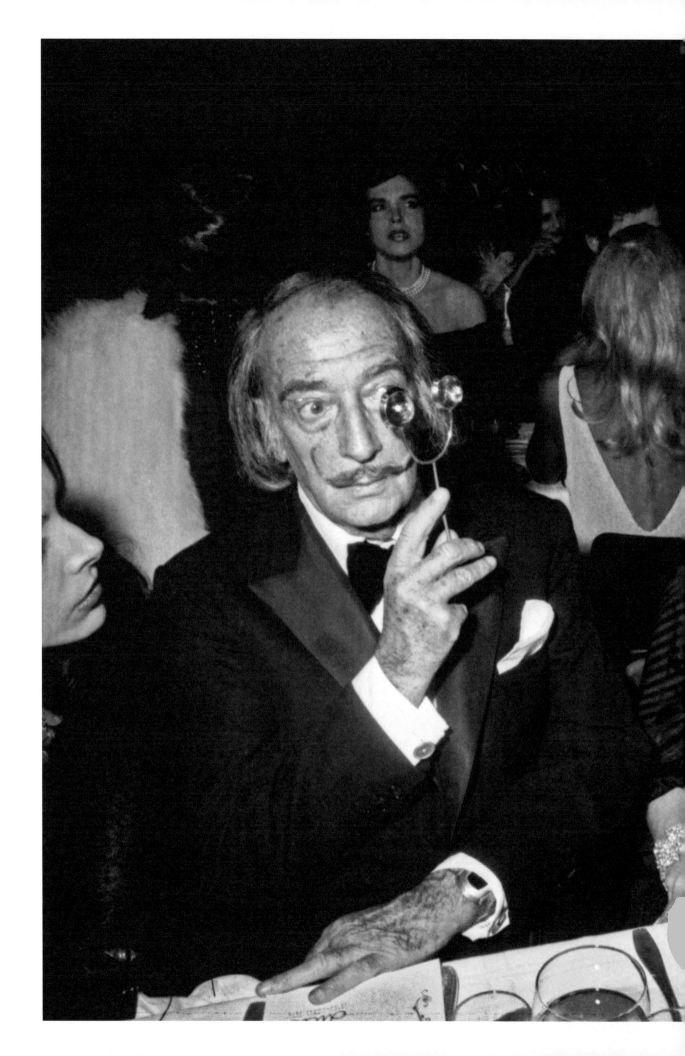

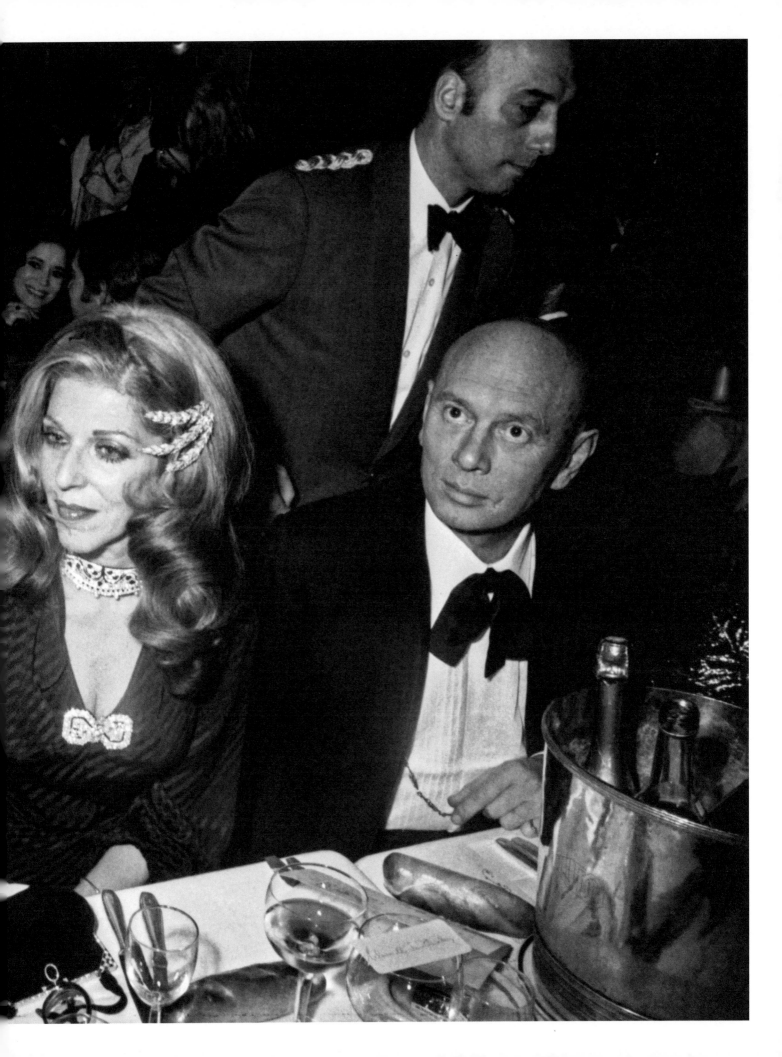

Fantasies

Yves Saint Laurent did not design dresses without considering jewelry. Although he did not sketch accessories often, he had a very precise vision of a whole look. To create the fantastical things he imagined, the couturier surrounded himself with talented artisans, such as the goldsmith Robert Goossens and the costume jeweler Roger Scemama. S. M.

Previous spread:
Salvador Dalí, Marie-Hélène de Rothschild, and
Yul Brynner attending the premiere of the revue
Grand Jeu presented at the Lido, Paris, December 1973.

Opposite:
Collection of accessories, bracelet, ring, and brooch,
spring/summer 1986, 1988, and 1989 haute couture collections.

"Jewelry is a complement to the clothing. With costume jewelry, you can create proportions pleasing to the eye. Yves wanted jewelry that had a visual impact. The most important thing was the line, the look, the woman in the garment. He staged it, magnified it. Jewelry was a sign of power."

Paloma Picasso

Original sketch of a tuxedo suit,
fall/winter 1988 haute couture collection.

georges

Le collier
un gardénia
en feuilles d'or
retenu par une
chaîne de grosses
perles
fronc d'or
a la taille

"For Yves Saint Laurent, gold was sculptural, with imposing structures. It was offbeat in a whimsical way."

Anna Klossowski

Evening dress worn by Tatiana Sinitsa, fall/winter 1993 haute couture collection. Photograph by Guy Marineau.

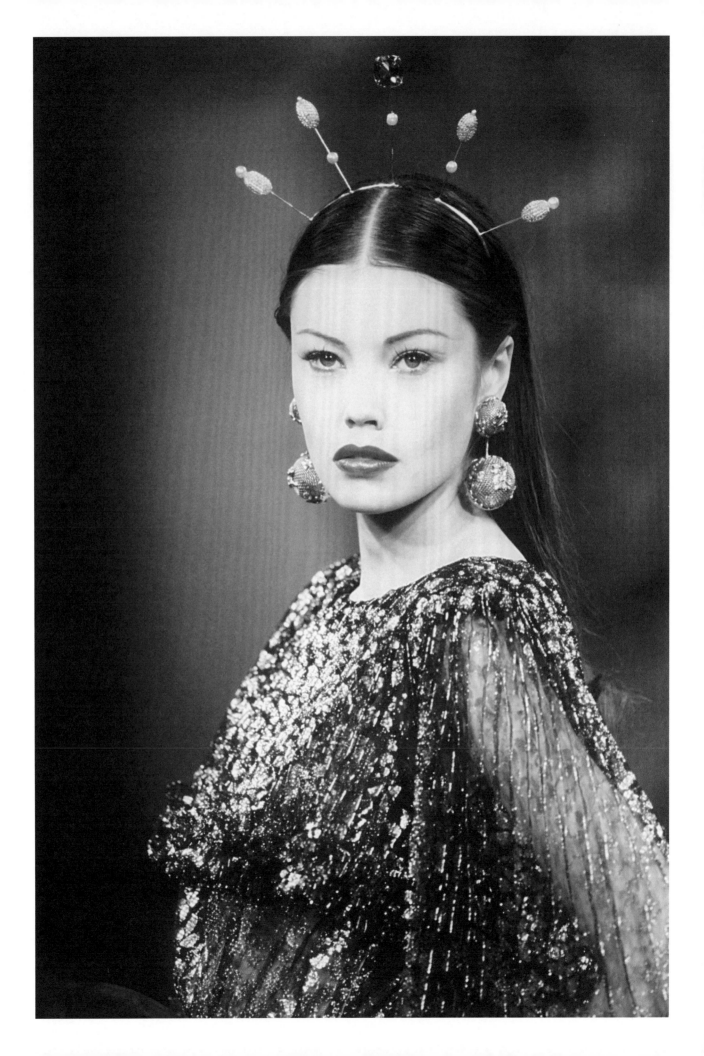

"His jewelry was Baroque, original, and imposing. You had to have personality to be able to wear them. You had to have powerful, self-confident women."

Marisa Berenson

Evening ensemble worn by Sadiya Guèye, fall/winter 1988 haute couture collection. Photograph by Guy Marineau.

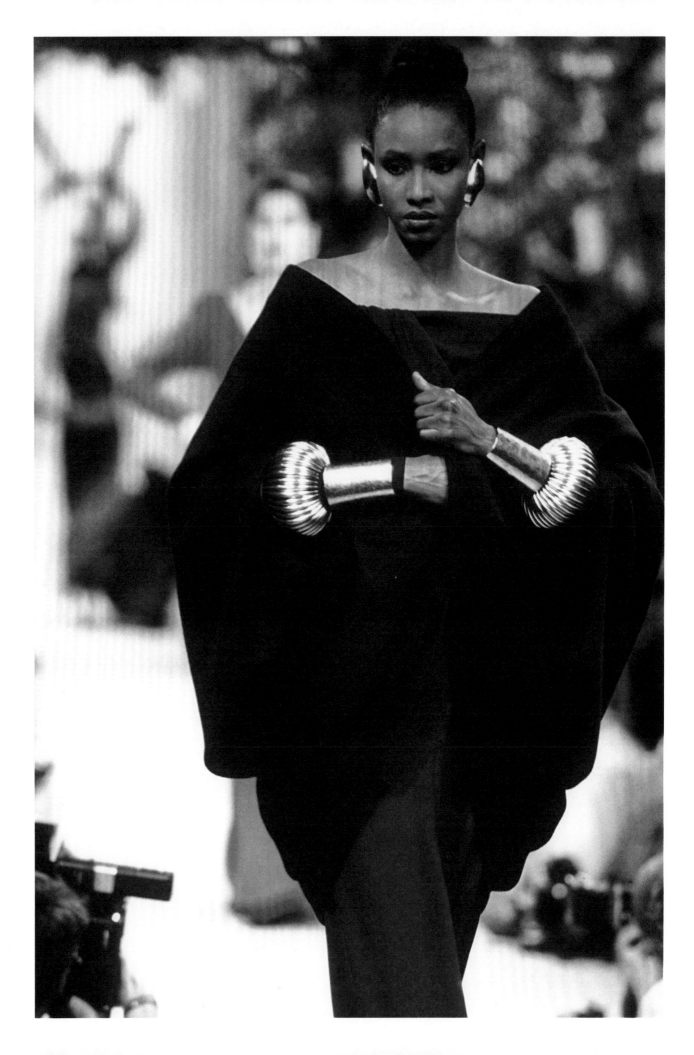

collier

Research sketch for accessories,
fall/winter 1988 haute couture collection.

Original sketch of a formal dress,
fall/winter 1988 haute couture collection.

Catherine

Voir
Collier

"A happy woman is a woman who doesn't need much. She must be comfortable in her clothes; that's why I love sweaters, scarves, and costume jewelry so much. I adore costume jewelry, gold chains."

Yves Saint Laurent, 1997

Yves Saint Laurent accessorizing the wedding dress worn by Mounia Orosemane, fall/winter 1980 haute couture collection. Photograph by François-Marie Banier.

"My mother made her adornments a veritable armor. This profusion of jewelry was both a good luck charm and protection."

Anna Klossowski

Loulou de La Falaise during the preparations for the fall/winter 1980 haute couture collection. Photograph by François-Marie Banier.

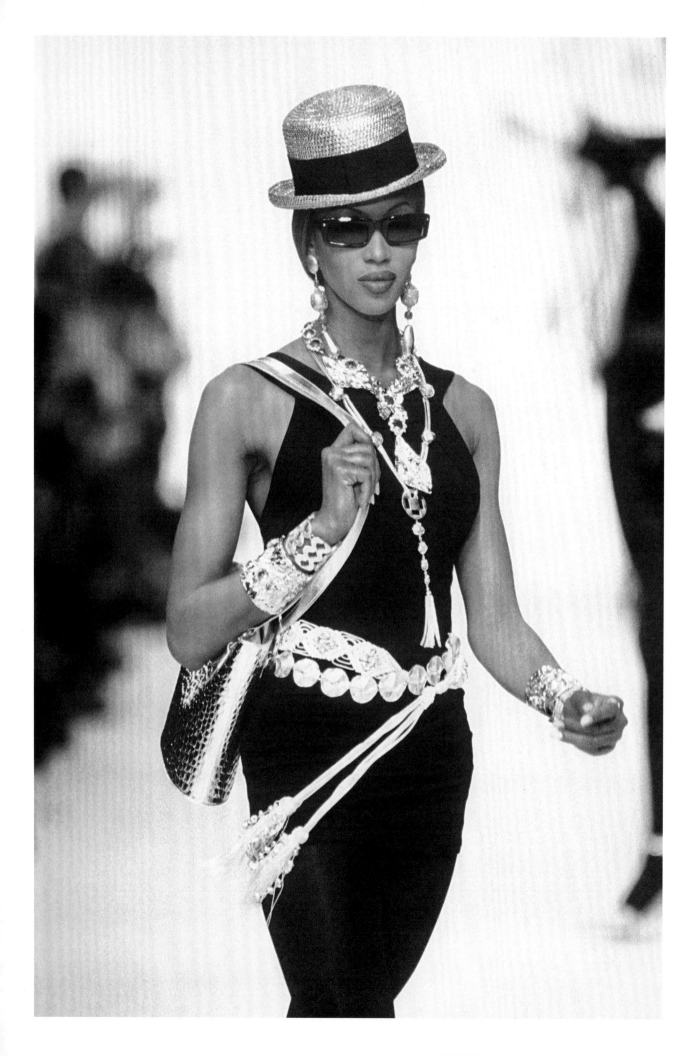

"No gemstones, no colors, no tawdriness. Just gold, or rather gilt, because I only like fake jewelry."

Yves Saint Laurent, 1997

"In the mid-1970s, I had a pair of golden leather boots, high-heeled boots, up to my knees. This is probably the accessory that I loved the most in my life. In a way, it was very insolent. Yes, Yves Saint Laurent had an insolence in the use of gold. He transformed a royal attribute into a bag or into shoes. Like a crime of *lèse-majesté*. A challenge to luxury, and a luxury at the same time."

Joan Juliet Buck

Collection of boots, fall/winter 1989 haute couture collection.

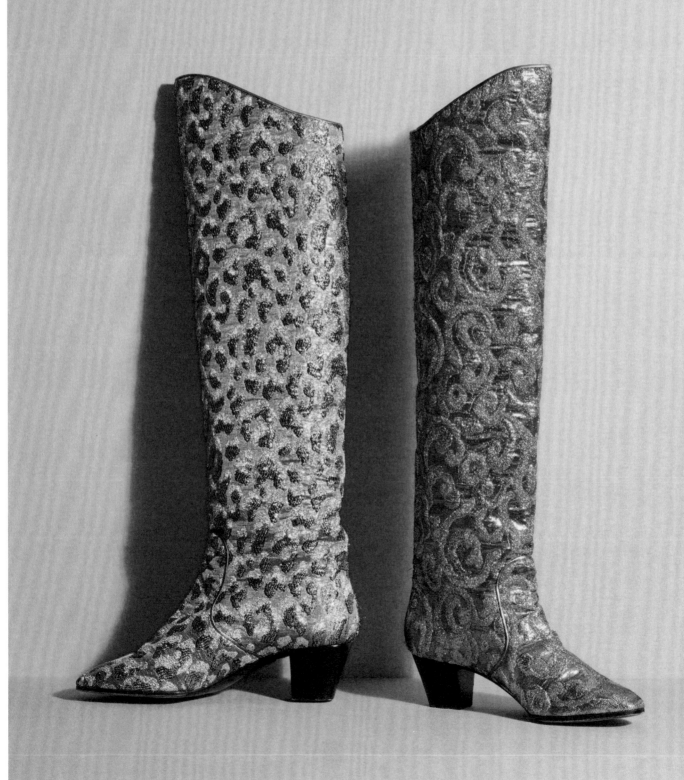

Zizi Jeanmaire

"Mademoiselle Jeanmaire shines. She has merely to step out onto the stage for everything to burst to life, into light and flames. This is the privilege of the music hall. The mere design of a silhouette can light up a room, the mirage, the dream." So said Yves Saint Laurent in 1977.

While working at Dior in 1956, Yves Saint Laurent met the dancer Zizi Jeanmaire, the companion of choreographer Roland Petit. A deep friendship was forged between the couturier and the legendary couple.

In 1961, Yves Saint Laurent designed the dancer's costumes for the ballet *La Chaloupée*. From that point forward, Zizi would rarely appear onstage dressed in anything other than Yves Saint Laurent. Her colors: black and gold. S. M.

Costume sketch for the music hall show *Zizi*, in a spectacle by Roland Petit at Bobino, Paris, 1977.

Following spread:
Collection of gloves, fall/winter 1977 and 1991 haute couture collections and fall/winter 1990 SAINT LAURENT *rive gauche* collection.

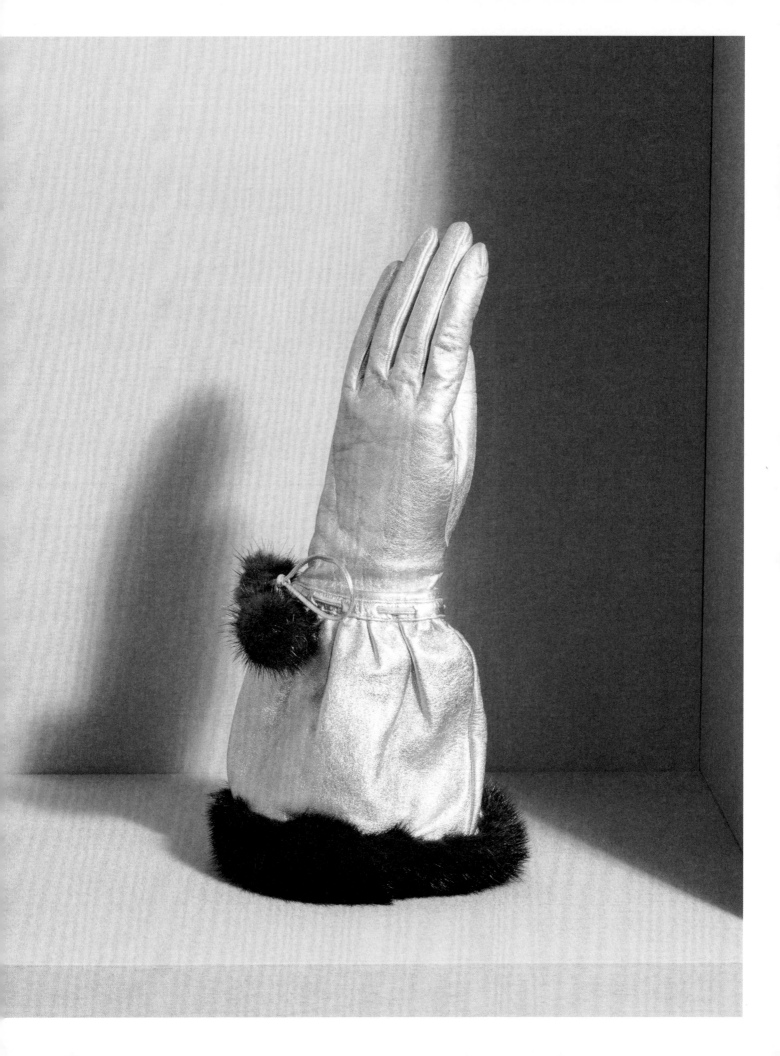

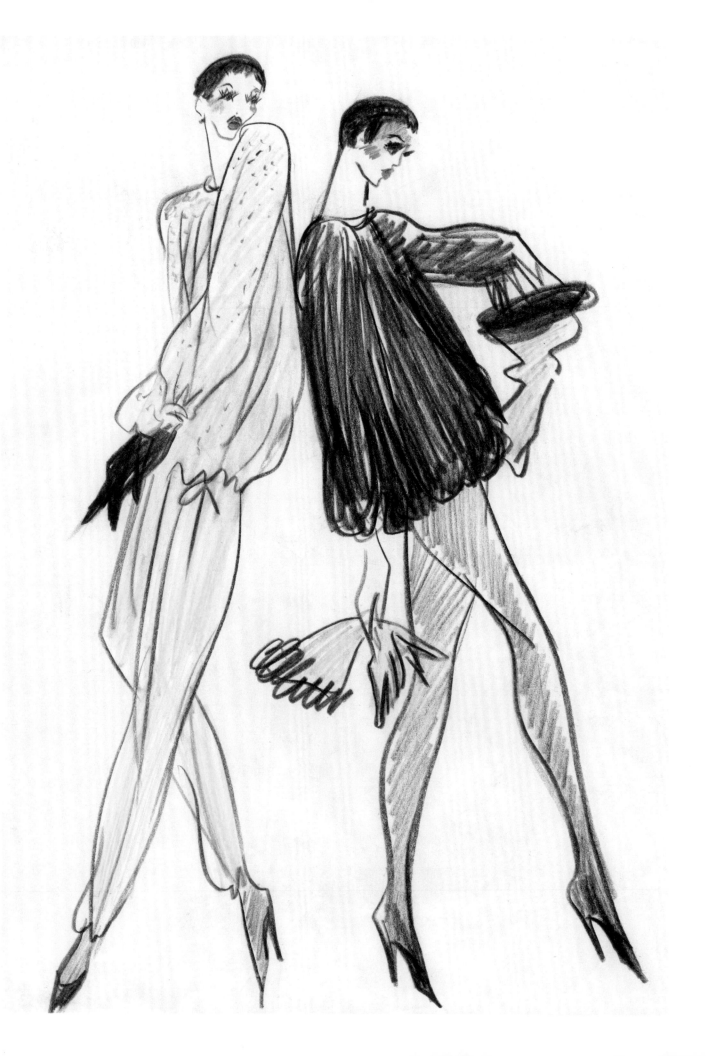

"With the exception of appearing as a reflection of moonlight and in the plumage of a macaw, Mademoiselle Jeanmaire, throughout her singing career, appeared only in black and gold. These were her colors. The simplest black, the one that exalted her. Around it were accents, flashes, luminous fireflies that were enough to evoke the most sumptuous spectacles. By avoiding all the trappings of the past, without realizing it, I fell into hers. But I'm not complaining! A magic of light and shadow! The very one of the theater!"

Yves Saint Laurent, 1977

Sketch of costumes for the music hall show *Zizi*,
in a spectacle by Roland Petit at Bobino, Paris, 1977.

129

Sylvie Vartan

Among the ten outfits created by Yves Saint Laurent for the actress and singer Sylvie Vartan for her three concerts at the Olympia in 1968, 1970, and 1972, two were golden jumpsuits. One was made in 1968, the other in 1972. The first, with a round neck and short sleeves, was reminiscent of the jeweled dress photographed by David Bailey for *Vogue Paris* in 1966. It appeared on the cover of the album *Sylvie à Tokyo* in 1972.

The second, shown here, revealed an athletic body. An irresistible look, an iconic boldness, a plunging neckline, and a rock attitude—the teen idol was clad in seduction. The carnal dance choreographed by the American Howard Jeffrey, including shirtless dancers, marked one of the highlights of the Olympia of 1972. Broadway musicals served as inspiration for the show, and the French star gained sex appeal. As sensual as it was comfortable, this outfit would be worn by the singer on many occasions, including for the duet "Te tuer d'amour" with Johnny Hallyday. S. M.

Sylvie Vartan wearing the jumpsuit designed by
Yves Saint Laurent during her concert at the Olympia in Paris,
October 1972. Photograph by Patrick Jarmoux.

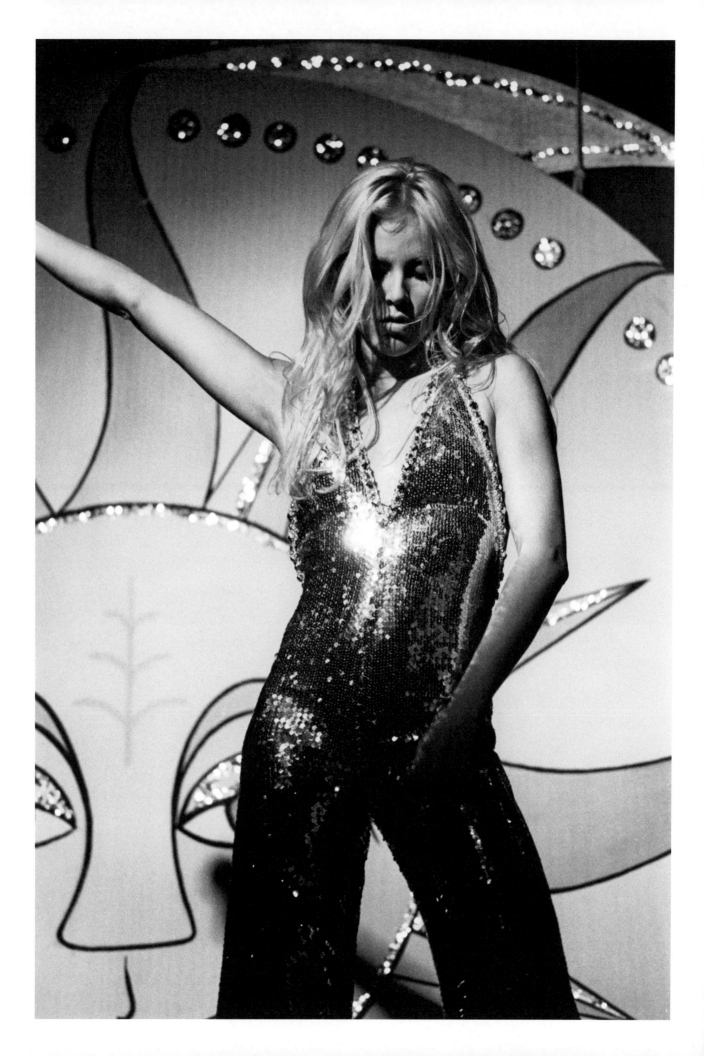

Yves Saint Laurent

DREAMER

In 1956, Yves Saint Laurent worked at Christian Dior. He designed what would be the most observed collections in the world. As a way to relax, he created the naughty character *La vilaine Lulu*. She was an awful, irreverent little girl, an exhibitionist who drank Scotch when she woke up and took baths with a rat. "We were young and having fun," explained the designer. "Often, after six o'clock, a colleague of mine at Dior would dress up. One evening, he had pulled up his pant legs to his knees. I remember he was wearing long black socks. He found a red tulle petticoat in the dressing room and a gondolier's hat. Appearing very small, almost disturbing with his stubborn and cunning attitude, he impressed me, and I told him, "You are la vilaine Lulu." Lulu was so naughty that her adventures, which became a comic strip the couturier published a decade later, caused a scandal. What emerged from these storyboards, in the same way as his discussions with those closest to him, was the couturier's sense of humor. Yves Saint Laurent liked to laugh and joke. This is one of the lesser-known traits of his personality. When asked, "What do you appreciate most about your friends?" he would answer, "Joy." "Some of Yves's qualities, such as his authoritativeness and cheerfulness, are never highlighted," said Pierre Bergé. Happiness and pleasure also guided him. To be completely convinced, one need only look at his photos as a young man. Yves Saint Laurent was beautiful. There was something magnetic about him that seduced those who approached him. He had a gentle way of expressing himself and a smile that often ended in a delightful chuckle; he mastered this innate, inexplicable art of seduction. In 1959, while appearing on television, Yves Saint Laurent spoke about a red chiffon dress, "very young, very cheerful, a little flashy,"[1] and it felt as if he were talking about himself. "We instantly recognized this chicness he had. He was a charming designer, a man, a dreamer who had a very particular idea of fashion,"[2] recalled Edmonde Charles-Roux in 1962. In August of the same year, Le Monde reported that his collection was "the most applauded."[3] Bravos, accolades, joy!

Yves Saint Laurent spoke of style and attitude rather than fashion with his collections. He created an allure. At ease, the woman is self-confident, powerful, and sensual. She is luminous. Catherine Deneuve, and her blond hair cascading over the shoulders of a black Le Smoking, was the most sublime image. The couturier also wore his own creations. Tanned and relaxed in his safari jacket, he enjoyed life's pleasures. Yves Saint Laurent was a child of the sun, the sun of Oran that he rediscovered in Marrakech in the mid-1960s. The Swinging Sixties was a crucial decade. Yves Saint Laurent lived during a time in which he witnessed freer lifestyles and shortened skirts. He stripped the legs and wrapped them in gold tights. In 1966, he created SAINT LAURENT rive gauche and opened the first shop in Paris, where his life-size portrait by the artist Eduardo Arroyo was displayed. With this ready-to-wear line, the couturier provided himself a new space for freedom, less constrained by the rules of haute couture, where, as a risk-taker, he could put on a performance and take in the light. "I like the eccentric, the funny, the unexpected,"[4] he once said. But work had taken up so much of his time. "I immediately had a lot of responsibility, and what I wanted to do was silly things, in fact, while being wise." Dare. He posed naked in front of Jeanloup Sieff's camera in 1971 to promote a new men's fragrance and jokingly proposed to name it "Eau de Zizi" after the famous dancer. The name chosen was Rive Gauche.

1 Interview during television news, February 1, 1959, RTF.
2 *Cinq columns à la Une*, September 7, 1962.
3 *Le Monde*, August 1, 1962.
4 *L'Écho d'Oran*, January 7, 1955.
5 Quoted in Laurence Benaïm, *Yves Saint Laurent*, Paris: Grasset, 2002.
6 Advertisement for Opium, October 1977.

The name said so many things. In 1993, the new Yves Saint Laurent perfume was called Champagne, "for women who sparkle." A court decision eventually prohibited the use of the name, but the initial idea of a bottle resembling a bottle of Champagne topped with a golden cork summed up an entire state of mind. In the couture house, it was not uncommon to celebrate happy events and the launch of a collection with bubbles. There was so much success to celebrate. Yves Saint Laurent was a regular among Parisian night spots. As a young man, he would go out to L'Éléphant Blanc and Le Fiacre. He would have fun in cabarets and revues and watch drag shows. It was at Chez Régine that the designer met Betty Catroux, his soulmate. With her and the rest of the "clan," he frequented the wildest places, including Le Sept, a nightclub of neon lights and mirrors where the entire world of fashion and the arts—Andy Warhol, Karl Lagerfeld, Kenzo Takada, Pierre Cardin, etc.—moved to the rhythm of disco. And then, of course, there was Le Palace and its hidden restaurant Le Privilège. Sequins, costumes, and incredible looks filled the room. Loulou de La Falaise organized evenings with evocative titles, "Monts et Merveilles" and "Ange ou Démon," to celebrate her marriage to Thadée Klossowski in 1978. For the occasion, star DJ Guy Cuevas painted his bald head in gold.

Gold was the material of night, and night was moments for glamour. Night was the opportunity to wear magical outfits, like Rita Hayworth in *Gilda*, who sang "Put the Blame on Mame" in a body-hugging long black dress designed by Jean Louis, the talented French costume designer from Hollywood. Yves Saint Laurent was seduced by these glittering, living fantasies who would slowly peel off their long gloves, finger by finger, before throwing them in the face of a fascinated public. "We need cheerfulness, humor, gratuitousness. Fashion must also be fun; it must help people play, change, and compensate a little for a world that can be so terrible, so gray, so hard, and in which they are condemned to live. We must also dress up their dreams, escapes, and follies,"[5] proclaimed the couturier as if reciting a manifesto. For those who loved the night, he wanted to promote movement without giving up light. His lamé dresses were fluid and light. Gold became a second skin. In 1968, he designed a transparent black chiffon dress that bared the chest. To accompany it were small gold heels and a gilt belt depicting a snake that was worn against the skin. The night is a time that is dangerous and full of possibilities, a time in which women lose themselves and who, all in gold, "give themselves to Yves Saint Laurent,"[6] according to an advertising slogan that accompanied the release of the perfume Opium in 1977. In his wise way, the couturier handled the delicate art of impertinence with ravishing irony and humor, sometimes bordering on the limits of political correctness, aesthetics, and bourgeois morality for which he often expressed criticism. The night and festive spirit were also moments for a certain taste for excess. As Betty Catroux recalled: "We lived for seduction. Seduction was our goal. What was charming and seductive were enormous pleasures for us. Then it was to have fun, every night. Just do fun things. Naughty. Drink. Excesses. Only those things that people don't do anymore. Live only for fun. To enjoy all the charms of existence, to seize every moment, to experience pleasure and to give it." This was also the life of Yves Saint Laurent.

Yvane Jacob

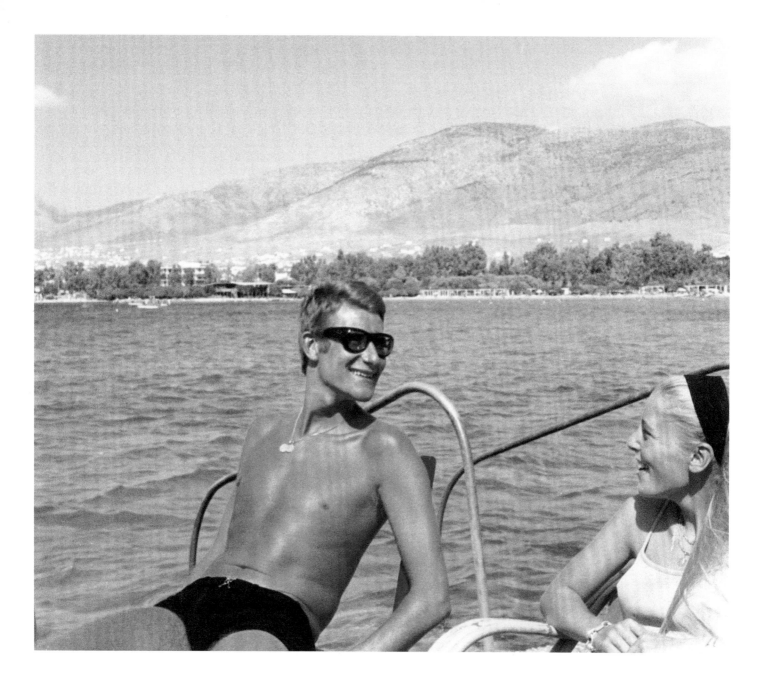

Yves Saint Laurent, 1964.

Collection of necklaces, spring/summer 1987 haute couture collection.

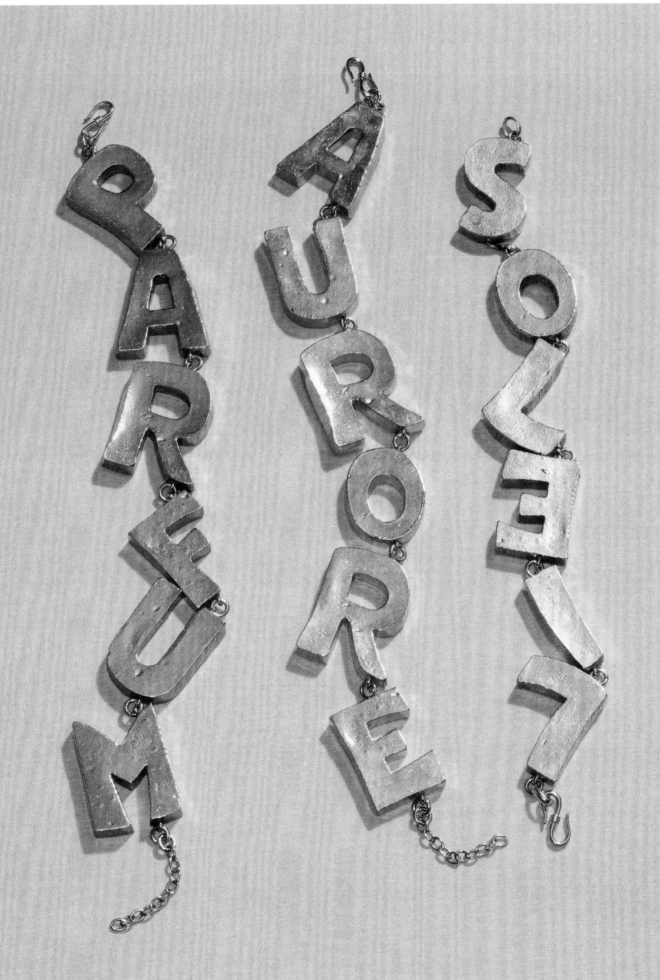

Marrakesh, a City of Light

In 1966, Yves Saint Laurent and Pierre Bergé visited Morocco for the first time together. "One morning we awoke, and the sun had appeared. A Moroccan sun that probes every recess and corner. The birds were singing, the snowcapped Atlas Mountains blocked the horizon, and the perfume of jasmine rose to our room. We would never forget that morning, since. in a certain way, it decided our destiny." Pierre Bergé described their shared passion for Morocco.

In Marrakesh, Yves Saint Laurent drew inspiration for his collections. This city taught him about color. "I embraced its light, its provocative combinations, and its intense creations." The couple spent many happy moments in their homes there: Dar el-Hanch (the House of the Snake), Dar Es Saada (the House of Happiness in Serenity), and Villa Oasis.

The Jardin Majorelle and the Musée Yves Saint Laurent Marrakesh still bear witness to their love for this city of light. S. M.

Yves Saint Laurent and Betty Catroux, Marrakesh, 1970s.

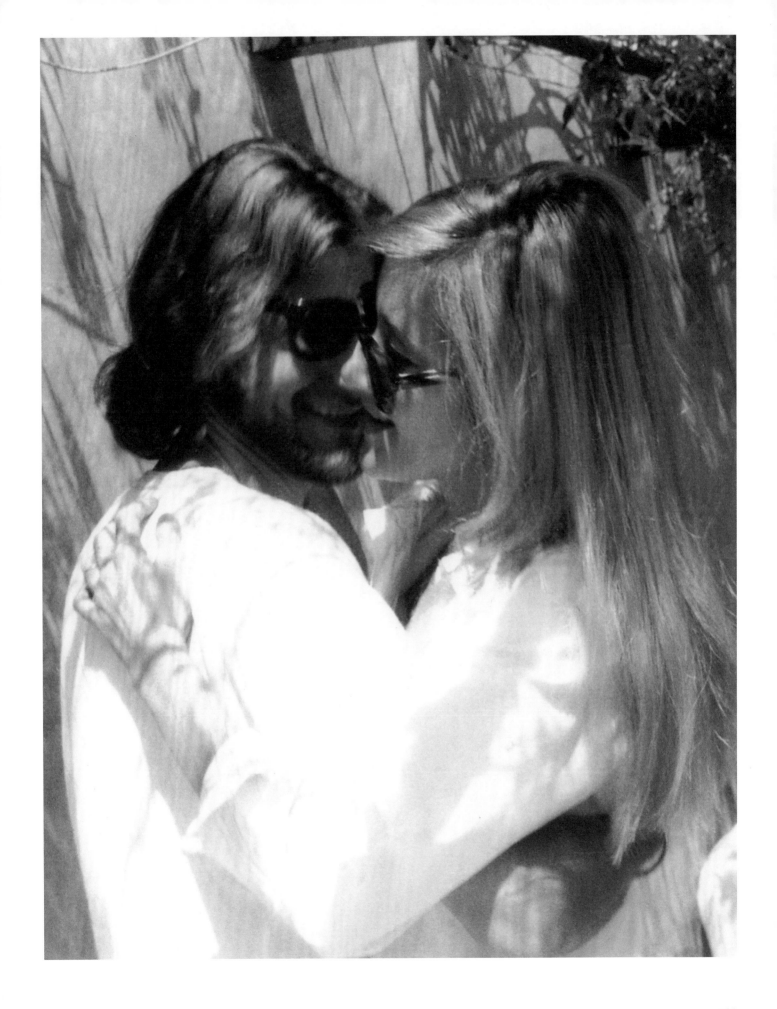

"Gold reflects the sun, the light. Consciously or not, it's something we are attracted to. Yves Saint Laurent's creativity was luminous. When they are inspired, when they work, artists are in the light, even when they suffer. Yves Saint Laurent was generous—he liked to share his talent—and that's how he accessed the light."

Marisa Berenson

Original sketch of evening ensemble, spring/summer 1988 SAINT LAURENT *rive gauche* collection.

cuir 02 chapeau
 soleil
 en
 Raphia

"Yves Saint Laurent loved light despite his shyness. He had a rock star side to him; he liked to be recognized, sign autographs. He had charisma, a magnetic power. A real strength emanated from him."

Dominique Deroche

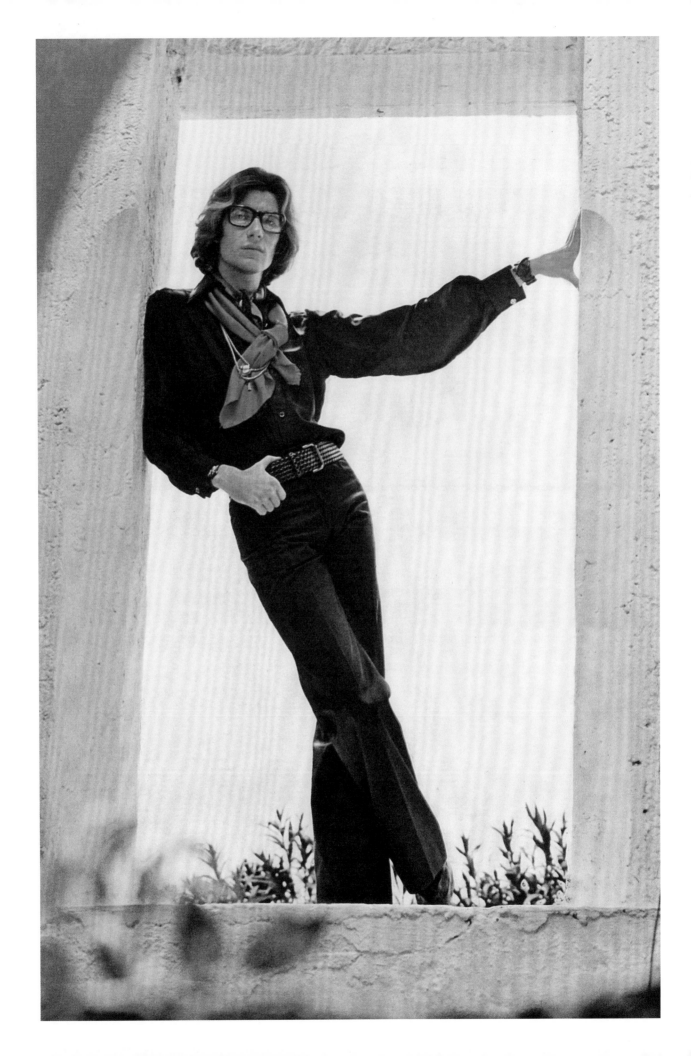

The Swinging Sixties

In the mid-1960s, Yves Saint Laurent redefined women's silhouettes by concealing the bust and waist in favor of the legs, more of which were now revealed. For the fall/winter 1966 haute couture collection, he showcased legs with his evening and cocktail dresses paired with sparkly Lurex tights in a golden color.

In tune with his time, which was undergoing an evolution of morals, sexual liberation, and women's liberation, Yves Saint Laurent created clothes that were minimally accessorized, built on softer lines, shorter lengths, and freer attitudes, facilitating movement and working toward a modern conception of femininity. Just as in London, fashion adopted codes from the street. Yves Saint Laurent understood this well and said in the program *Dim Dam Dom* in 1968: "I love everything about our times, and all this has an enormous influence on what I do."

The fall/winter 1966 haute couture collection, the tenth in his name, marked Yves Saint Laurent's appearance of gold in cocktail and evening ensembles. Often associated with one or more colors, gold highlighted the seams and animated the textile pieces with bright touches. For this same show, in a festive spirit, Yves Saint Laurent had fun dressing women in dresses embroidered entirely with sparkling sequins. The golden highlights on the daytime ensembles matched the sparkle of fabrics and embroidery for the evening ones, where all fantasies were allowed. A. C.-S. and D. É.

...les bas

YVESSAINTLAURENT

PARIS

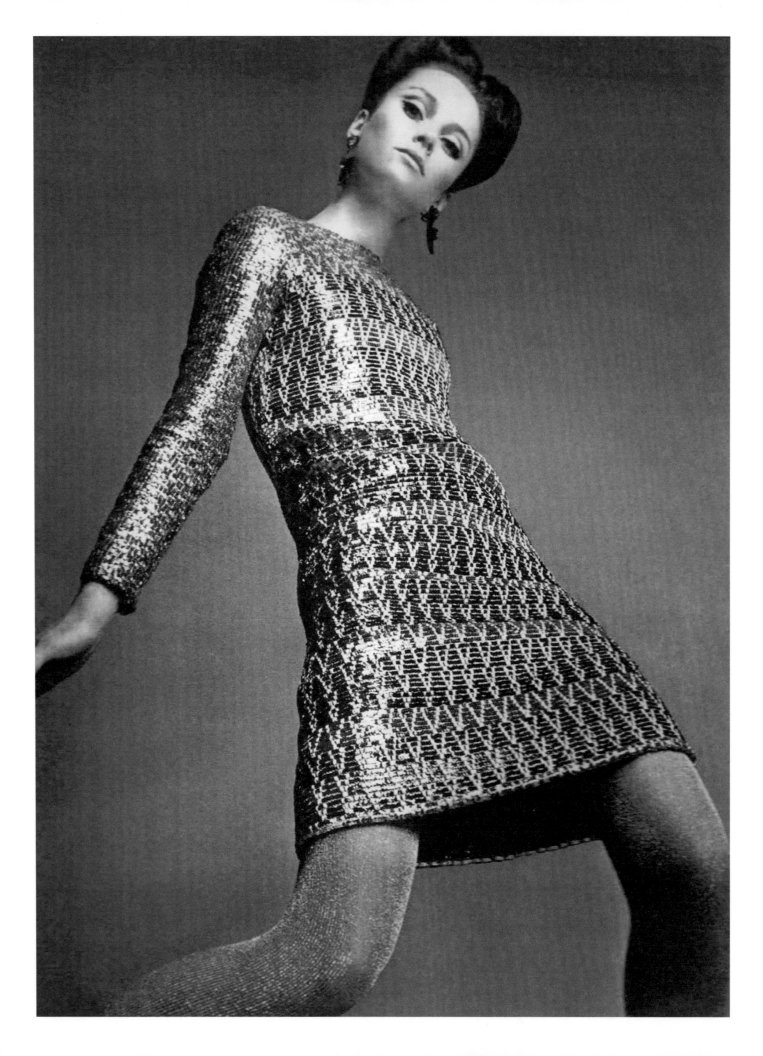

"I love legs, so why hide them?"

Yves Saint Laurent

Evening dress, fall/winter 1966 haute couture collection.
Photograph published in *L'Officiel*, October 1966.

Following spread:
Embroidered dress, fall/winter 1966 haute couture collection.
Embroidered evening dress, fall/winter 1967 SAINT LAURENT *rive gauche* collection.

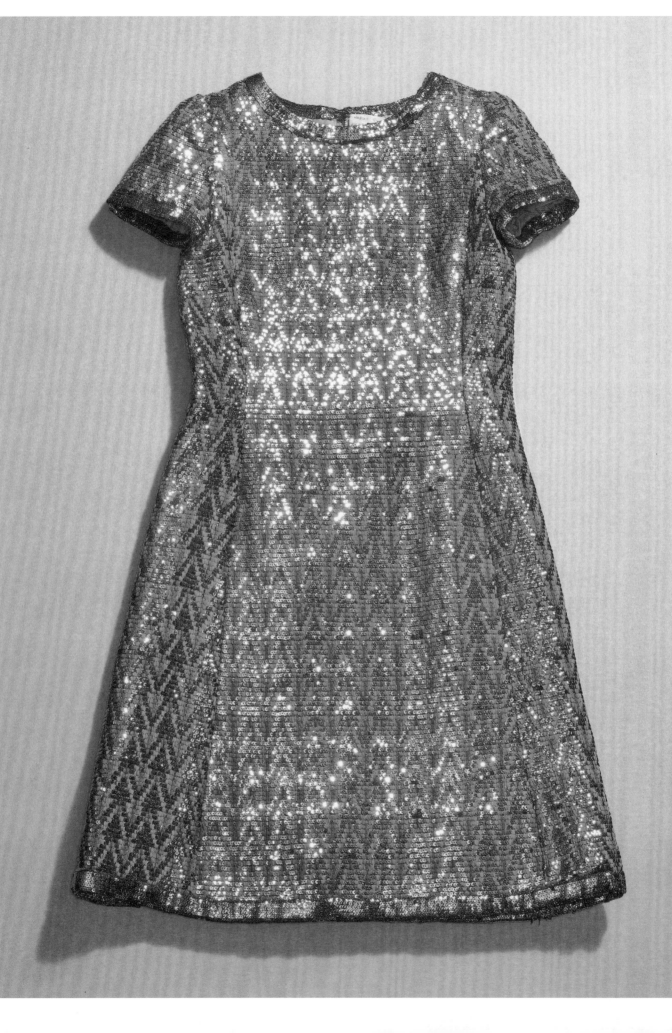

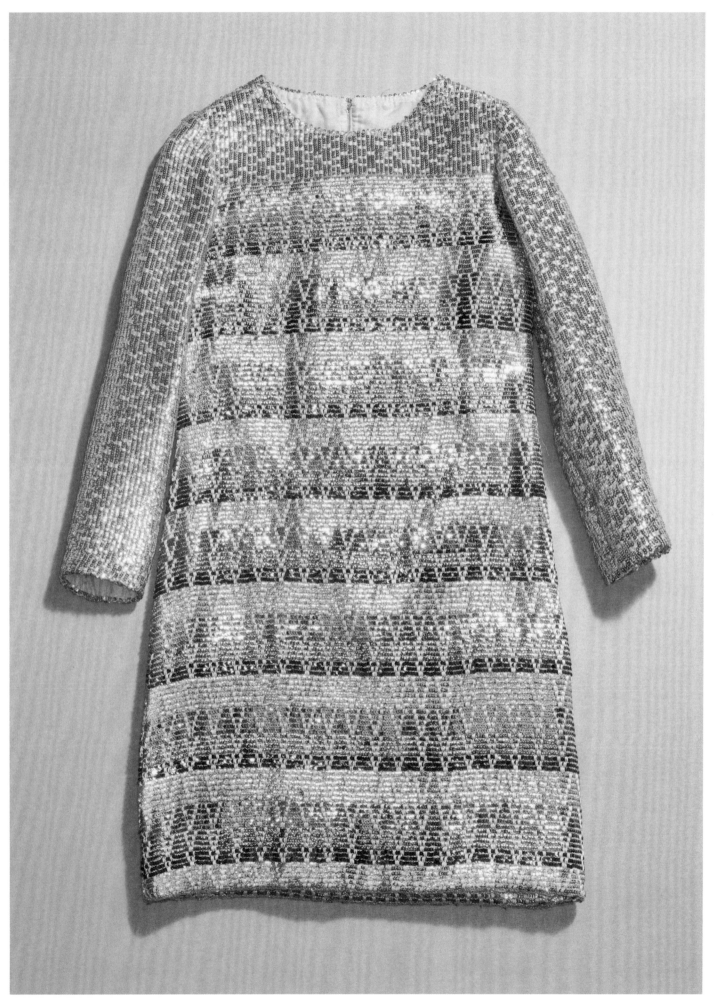

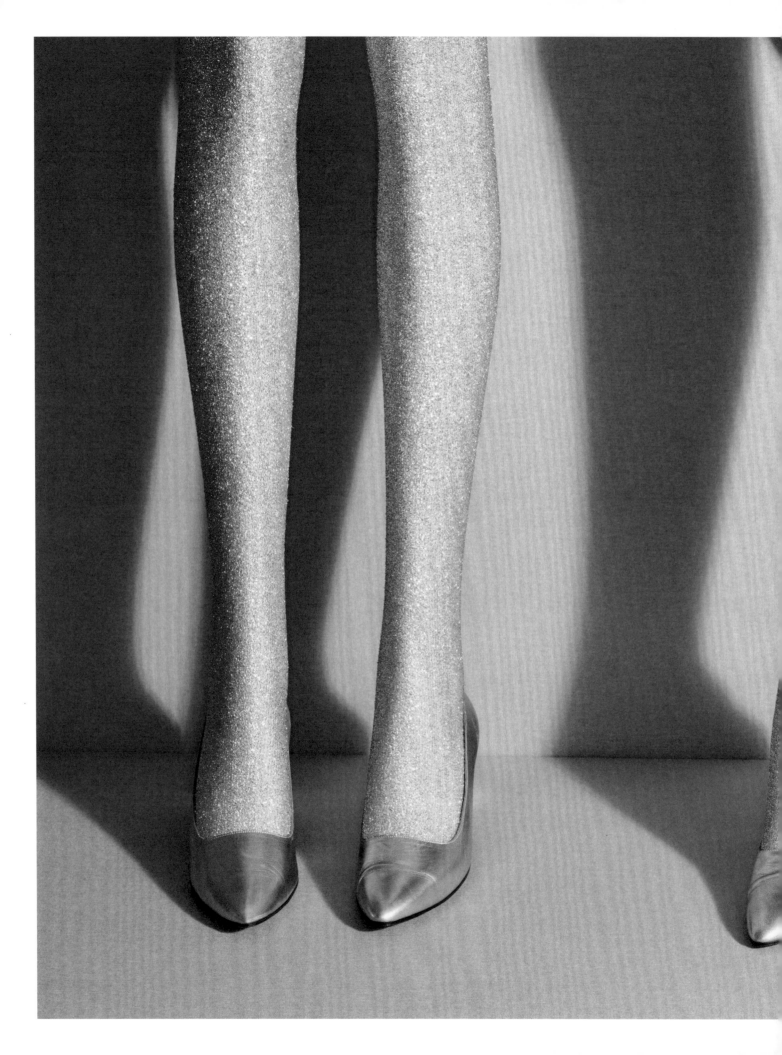

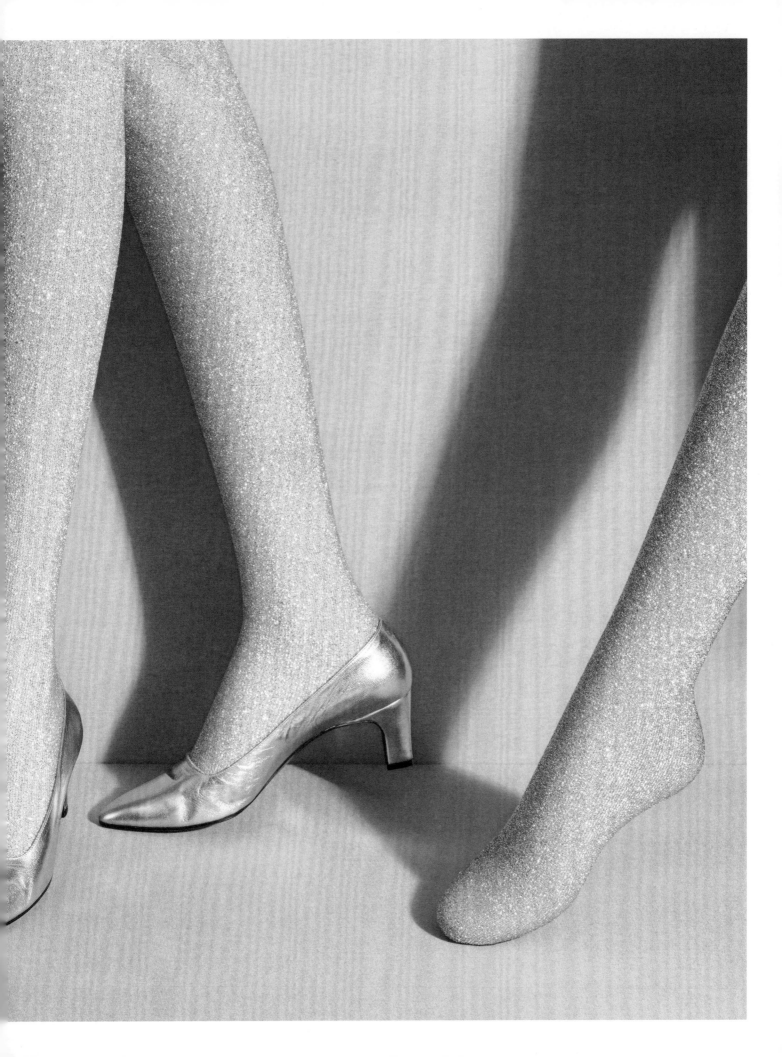

DEC. 6F.

VOGUE

PARIS

TOUT
EN
OR

UNE
MINE
DE
CADEAUX

DES
ROBES
BRILLANTES
A
TOUS
PRIX

BEAUTE:
LES
CELEBRITES
DU
MONDE
ENTIER

"For Catherine, whose golden sand hair in the vastness of a summer day personifies sweetness and tenderness."

Yves Saint Laurent

Previous spread:
Pairs of tights and shoes, fall/winter 1966
haute couture collection.

Opposite:
Catherine Deneuve wearing an evening dress, fall/winter 1966
haute couture collection. Photograph by David Bailey, cover of
Vogue (Paris), December 1966.

Jeweled Dress

Sarcophagus dress, jeweled dress, reliquary dress, a dress so light it could be a mermaid's dress: The interpretations of this dress, photographed by David Bailey for the December 1966 issue of *Vogue* (Paris), were many.

Playing with illusion—the belt and necklace were inlaid as trompe l'œil—this dress needed no other accessory. Covered in sequins and gems, it paid tribute to the famous flamboyant figure Cleopatra, the last queen of Egypt. Her portrayal in Joseph L. Mankiewicz's film *Cleopatra* (1963) seemed to be an obvious inspiration for the dress. Egyptian gold was as radiant as the sun god Ra, and the symbolic power of this dress seemed to tap into this divine energy. S. M.

Evening dress worn by Christa Fiedler, fall/winter 1966 haute couture collection. Photograph by David Bailey.

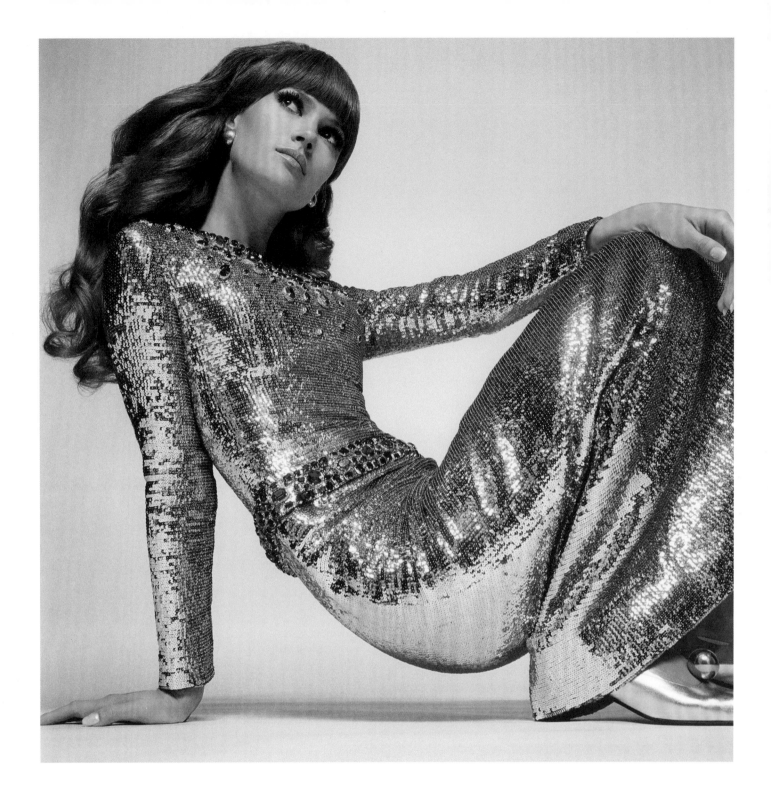

Champagne !

At the end of 1993, fifteen years after the scandalous perfume Opium was released, Yves Saint Laurent launched a new fragrance "for women who sparkle and make life sparkle": Champagne. The formula created by Sophia Grojsman was a harmony of fruits (emphasizing nectarine), florals, and sandalwood, an alchemy of original scents.

The bottle evoked the cork and wire cage (*muselet*) of a bottle of Champagne. Beyond its technical prowess, this glass bubble with hammered gold trim symbolized all the effervescence desired by the couturier. Champagne is an "exhilarating emotion that stuns, lights up faces, and creates eyes that sparkle," an "audacity of a name that explodes, bursts forth, departs like a mad laugh, and sends boredom packing," an "emotion shared for a moment longer than life."

The perfume Champagne was an immediate success. But soon after its launch, the name was prohibited. Legal proceedings initiated by the Comité Interprofessionnel du Vin de Champagne forced the brand to abandon the name, first in France and then throughout the world. Although the fragrance and the bottle remained unchanged, this "festive perfume" was first renamed Yves Saint Laurent and then, in 1996, became Yvresse.

S. M.

Champagne perfume, 1993.

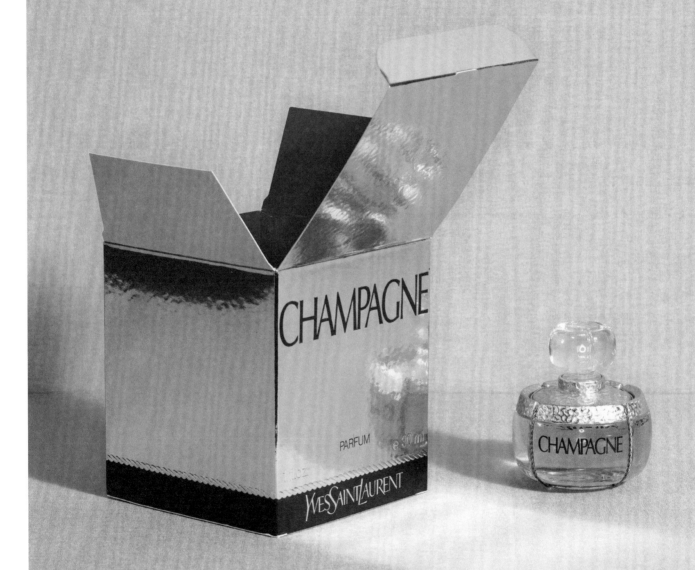

"Yves had an extraordinary humor, very incisive. He had a crazy spirit, a gift for capturing people and representing them in just a few strokes. He imitated, invented characters, played the clown … In happy days, he was only light."

Violeta Sanchez

Evening dress worn by Violeta Sanchez,
spring/summer 1981 haute couture collection.

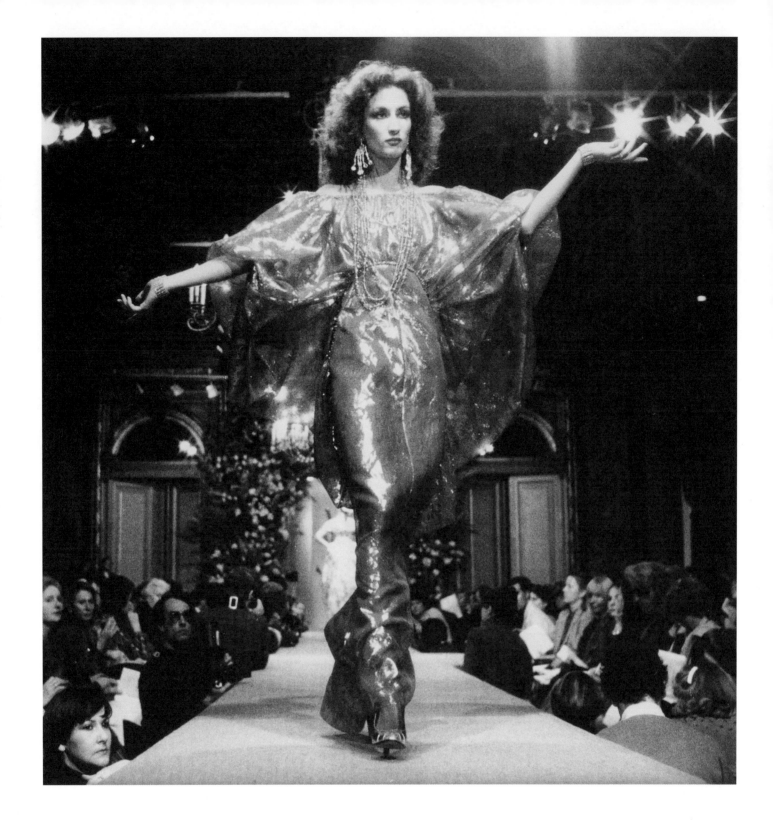

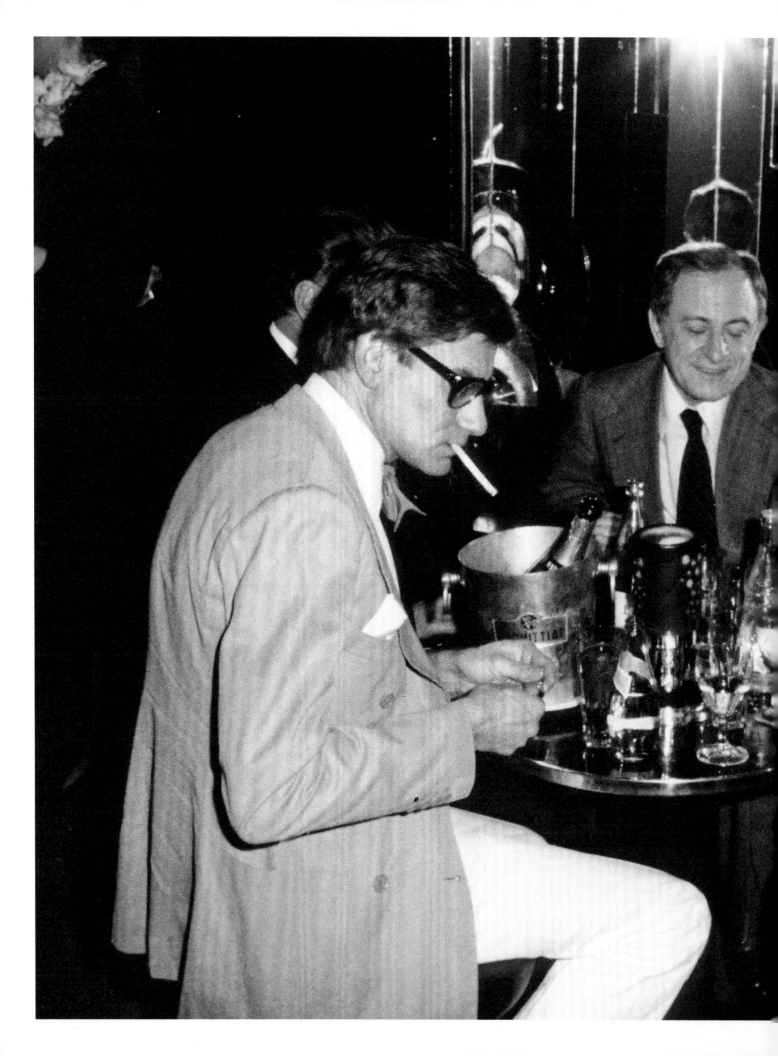

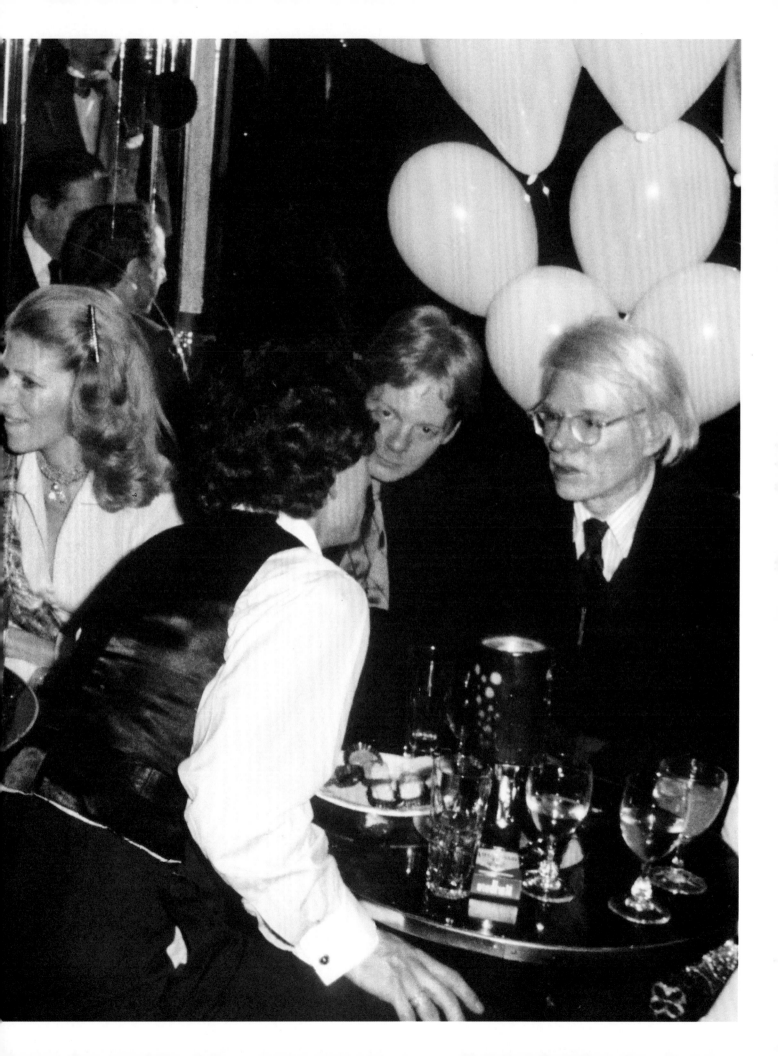

Parisian Nights

Starting at the end of the 1960s, Paris saw the emergence of fashionable party venues that revolutionized the world of the night. Everything seemed permitted in these new temples of pleasure, and creativity could be freely expressed. Wardrobes were glamorous and chic but also bold and extravagant. The invite set the tone for the opening of Le Palace on March 1, 1978: "Smoking, long dress, or as appropriate."

Yves Saint Laurent was a regular at Parisian nighttime hotspots. His evenings out with friends at Chez Régine, Le Sept, and Le Privilège were moments of joy and excitement. In 1967, he met Betty Catroux, whom he quickly considered his double, his twin, his accomplice. Inseparable, they experienced all the possibilities that these places could offer.

This festive atmosphere was one of the sources of inspiration for the designer, and gold, through its shiny and flashy appearance, naturally found its place. Yves Saint Laurent offered women a bright, colorful, and sensual wardrobe. From a simple detail to a total look, through a play of materials—lamé, leather, brocade—of techniques—gloved fabrics, embroidery, quilting—or associations with colors, gold pushes femininity to its limits. Dresses flowing like liquid metal, transparency blurred by golden fragments, plunging backs and necklines—everything was a pretext for the magic of the night!

A.C.-S., D.É., and J.L.

Previous spread:
Yves Saint Laurent, Pierre Bergé, Marie-Hélène de Rothschild, and Andy Warhol, Le Palace, Paris, 1977. Photograph by Michel Dufour.

Helmut Berger, Loulou de La Falaise, and Grace Jones, Le Palace, Paris, 1978. Photograph by Michel Dufour.

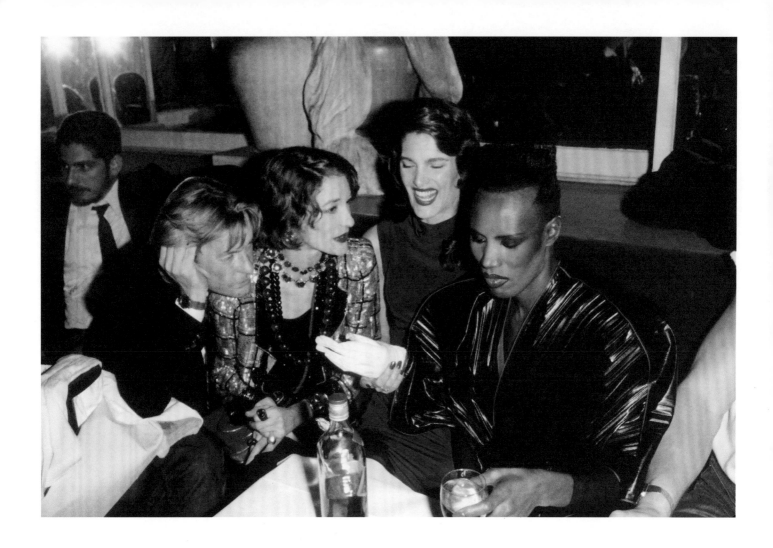

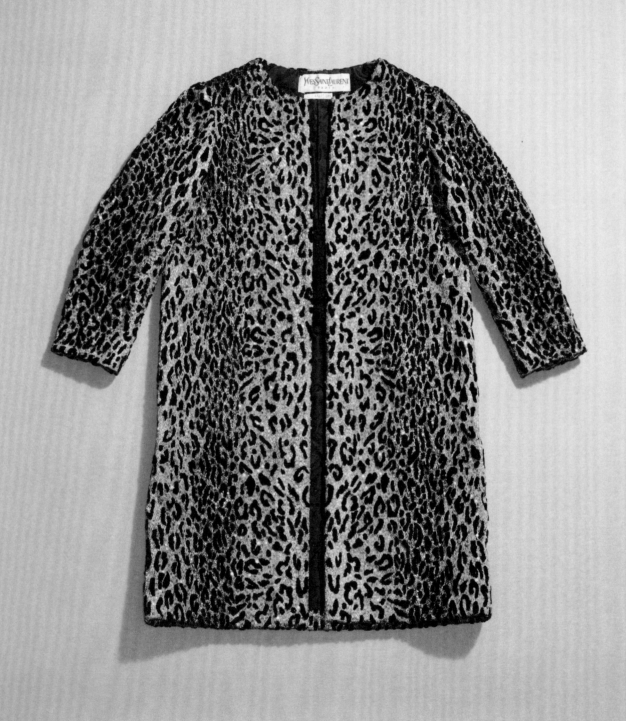

"I like muted colors during the day because I find that the light of Paris does not go well with bright colors, while in the evening I want women to be like birds of paradise."

Yves Saint Laurent, 1977

Coat of an embroidered evening tunic,
fall/winter 1964 haute couture collection.

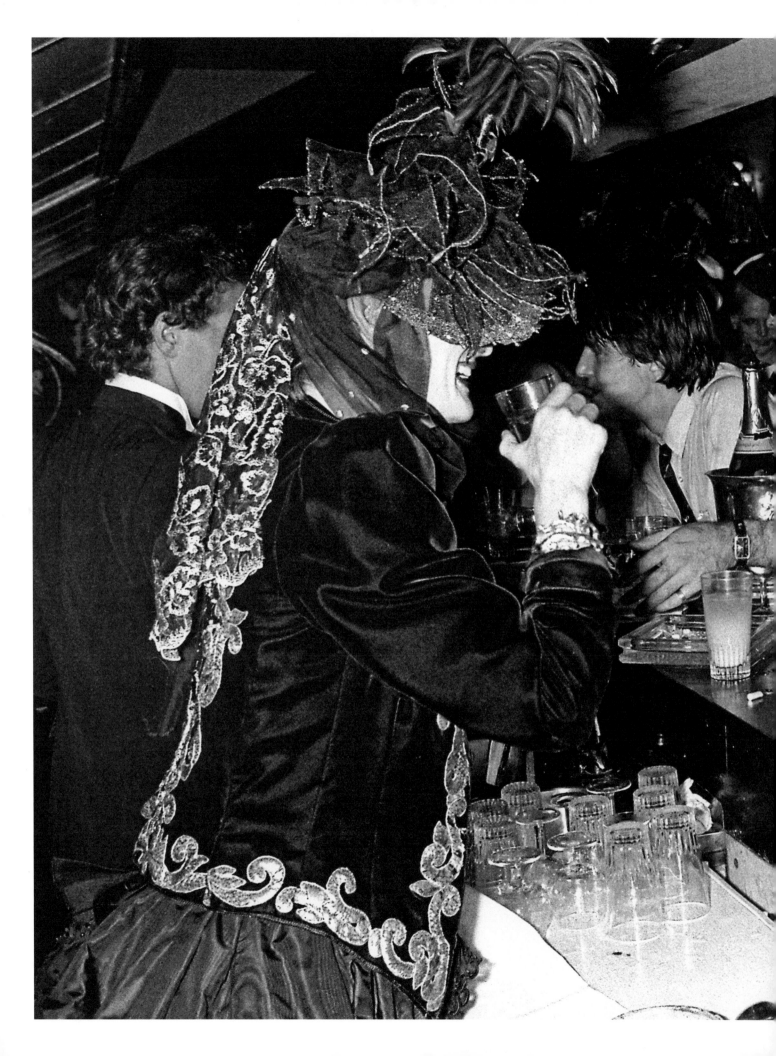

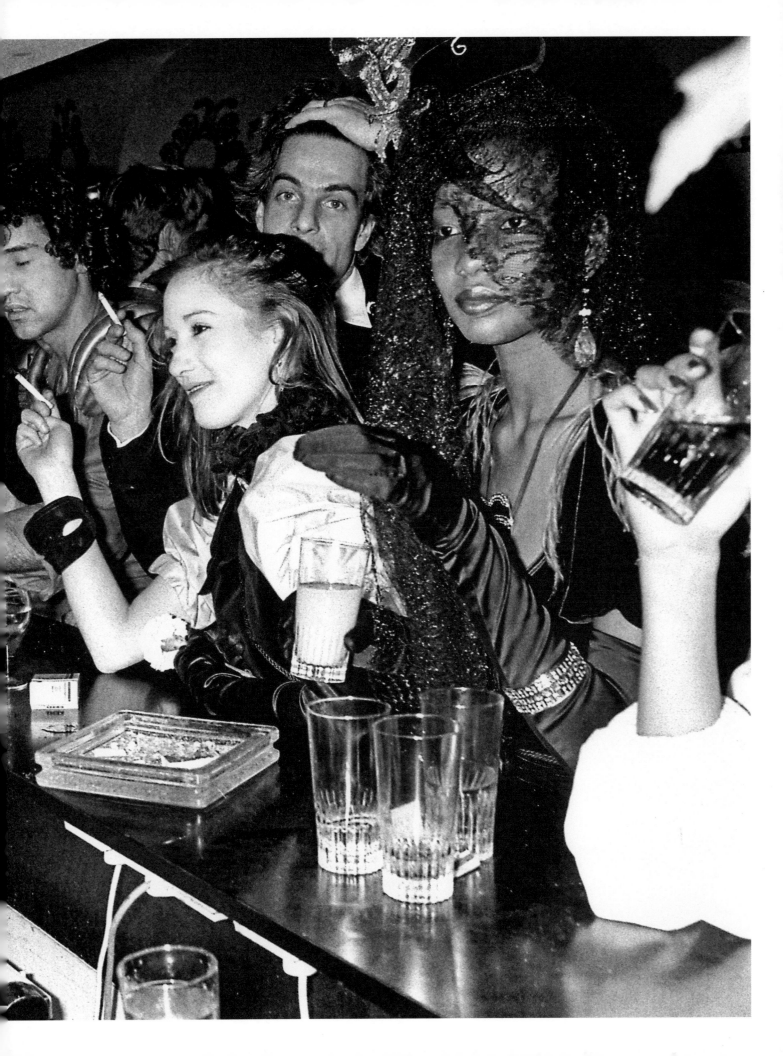

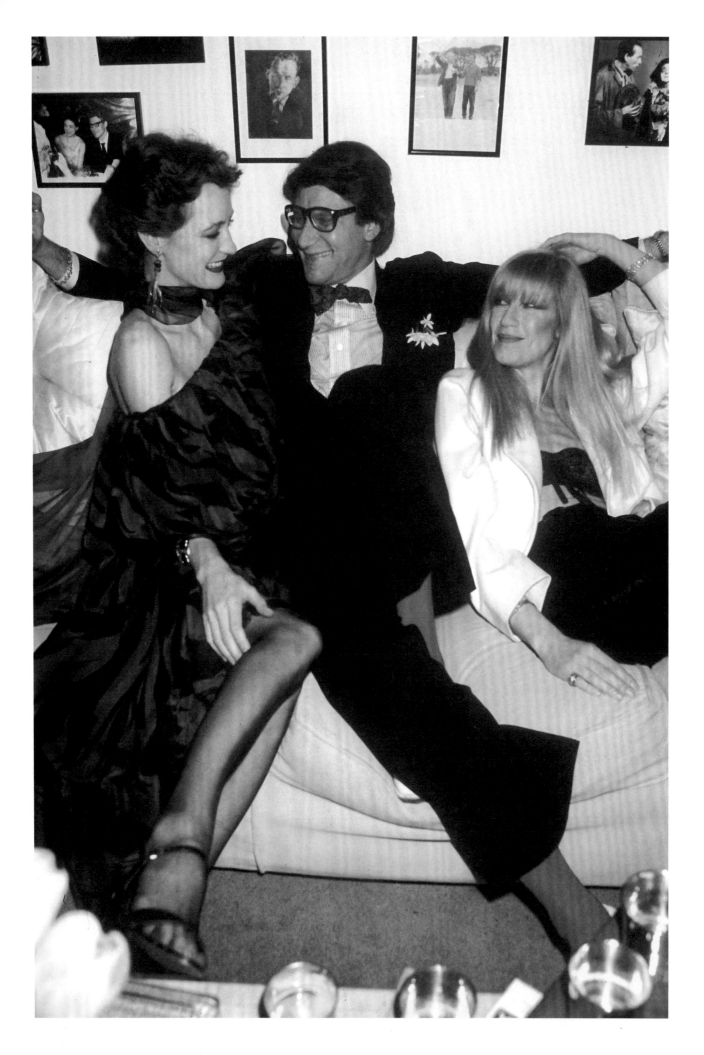

"An evening should glow; otherwise, it's a bit absurd. This is the moment of dreams, of light."

Yves Saint Laurent

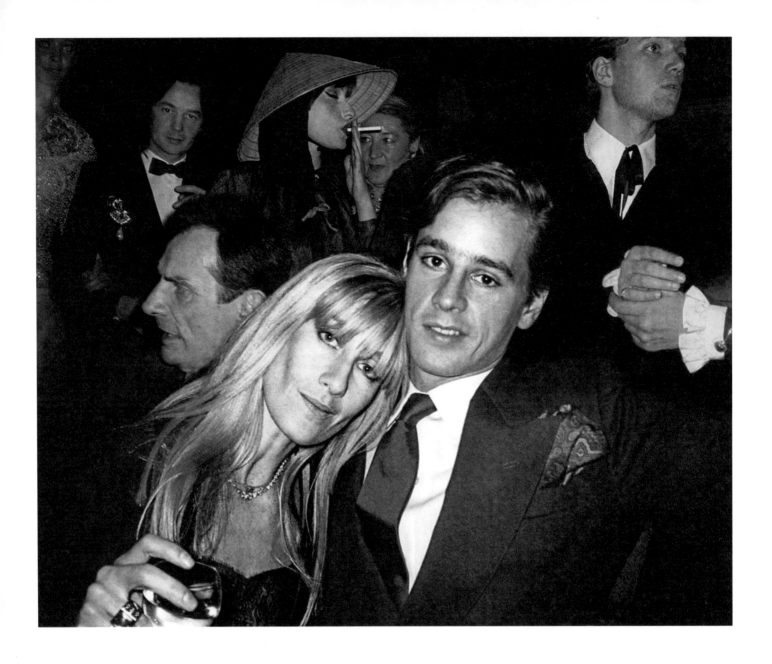

"I like to party. It's a joyous time. It shines. It sparkles. It bubbles. A glass of Champagne, gold from candelabras, gold on the walls, gold in the decorations . . ."

Yves Saint Laurent, 1991

Betty Catroux and Madison Cox, Le Palace, Paris, 1980.
Photograph by Philippe Morillon.

"We often had dinner together. It was a very carefree time, when we thought that everything would be fine, that the future would be wonderful, without borders, without wars. Yves was mischievous; he had something childlike about him."

Paloma Picasso

Embroidered evening bolero, fall/winter 1977 haute couture collection.

Following spread:
Francine Weisweiller, Yves Saint Laurent, Rafael Lopez-Sanchez, and Paloma Picasso at the launch party for the perfume Kouros, Opéra-Comique, Paris, February 23, 1981. Photograph by Maurice Bensimon.

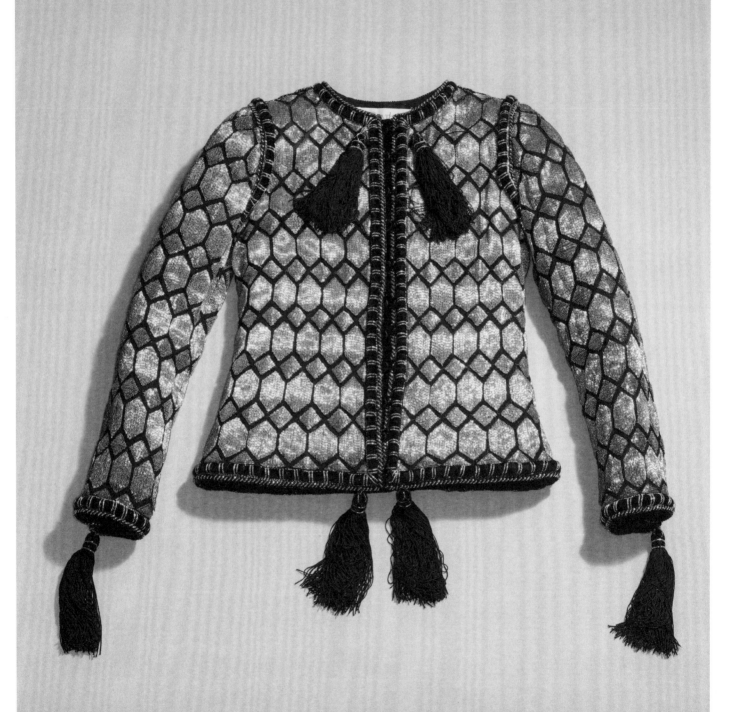

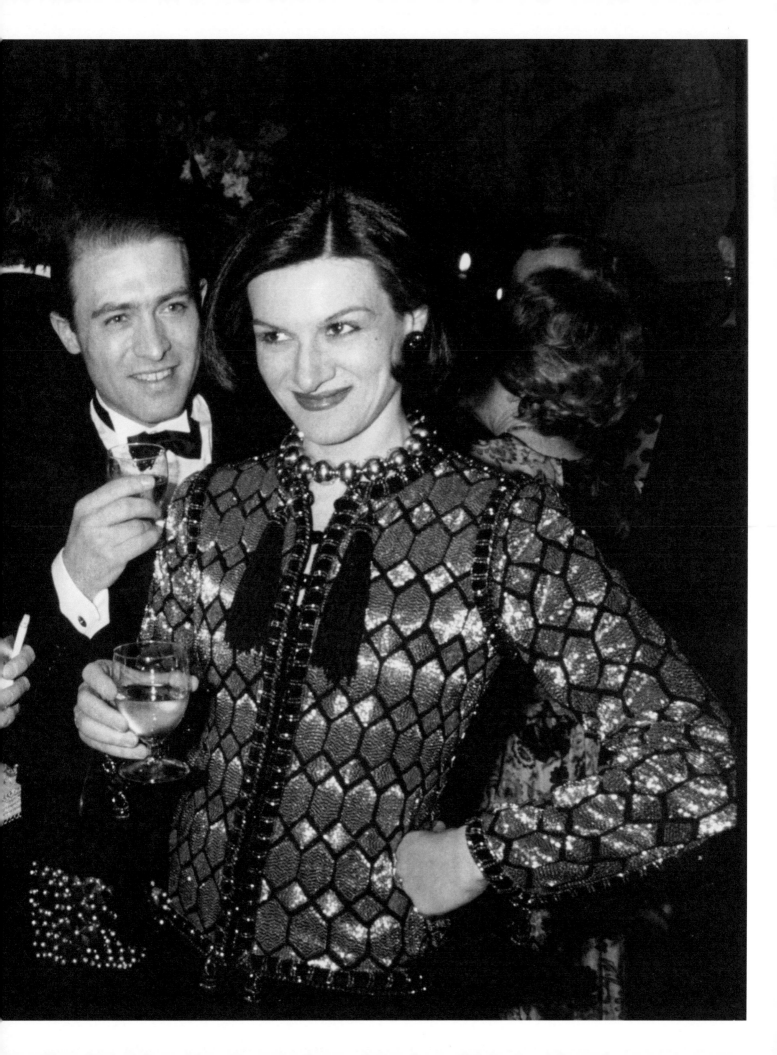

"Every morning, Yves phoned me to ask where we were going that night. We talked about the stupid things we were going to do, like two four-year-olds. We were just laughing. We were like two bad boys."

Betty Catroux

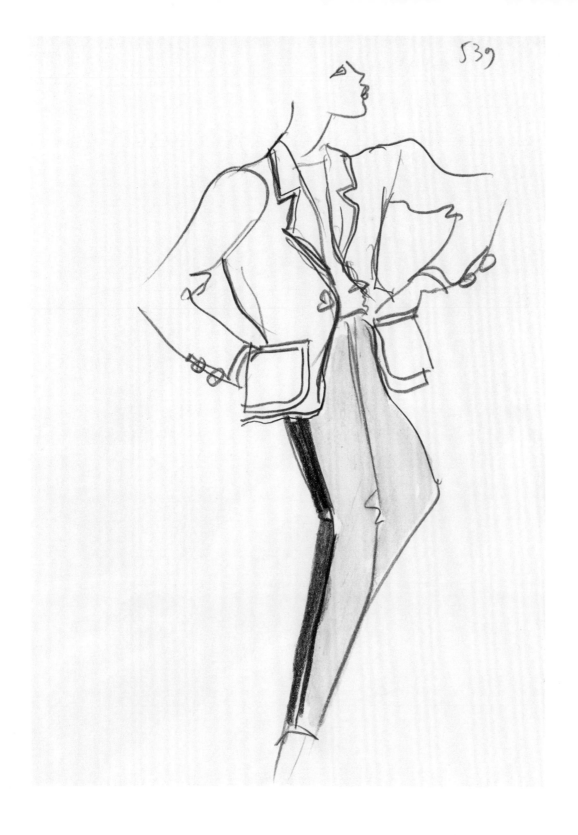

539

Original sketches of an evening ensemble, spring/summer 1988
SAINT LAURENT *rive gauche* collection.

Following spread :
Chrystèle Saint Louis Augustin, Carla Bruni, Yves Saint Laurent, Karen
Mulder, and Alix Mouret, backstage at the spring/summer 1996 haute couture
show. Photograph by Bertrand Rindoff Petroff.

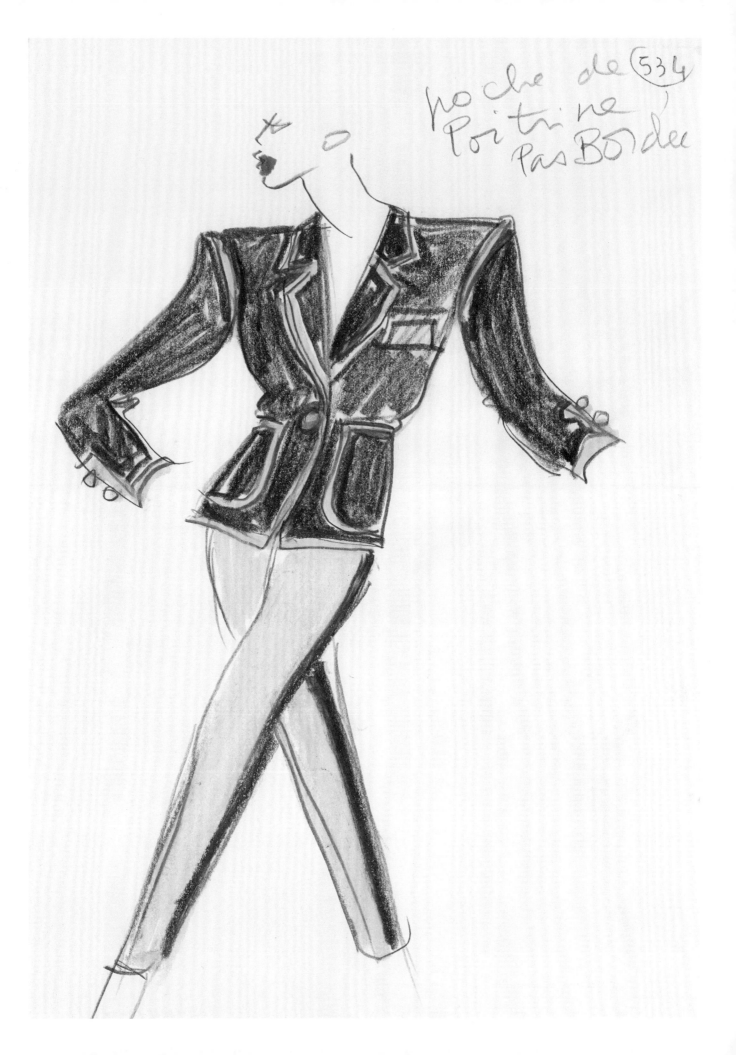

poche de (534)
Poitrine
Pas Bordée

"One night, I had to pick up Madame Saint Laurent [Yves's mother] for dinner at a mutual friend's house. She had told me on the phone, 'Dress discreetly,' because we were going to a neighborhood she did not know. While I was waiting for her downstairs, I saw her come out in a flamboyant golden leather trench coat. She was gorgeous, elegant, and visibly convinced she was discreet."

Gabrielle Busschaert

Leather trench coat, fall/winter 1980 haute couture collection.

Following spread:
Yves Saint Laurent and Lucie Richards at the end of the
fall/winter 1991 SAINT LAURENT *rive gauche* fashion show.

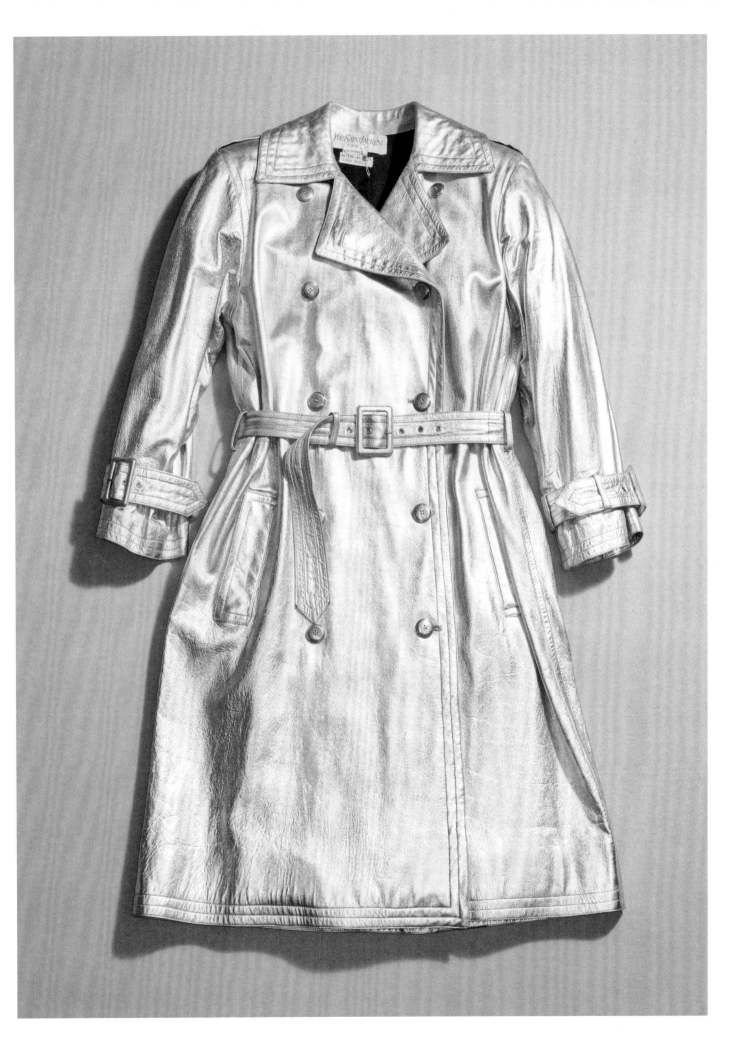

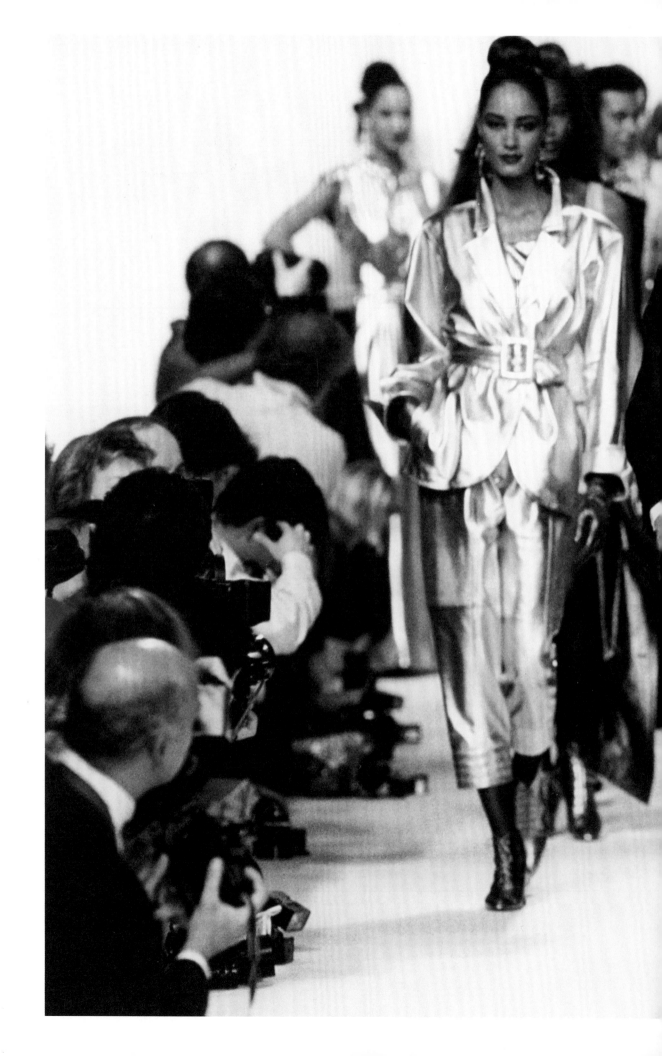

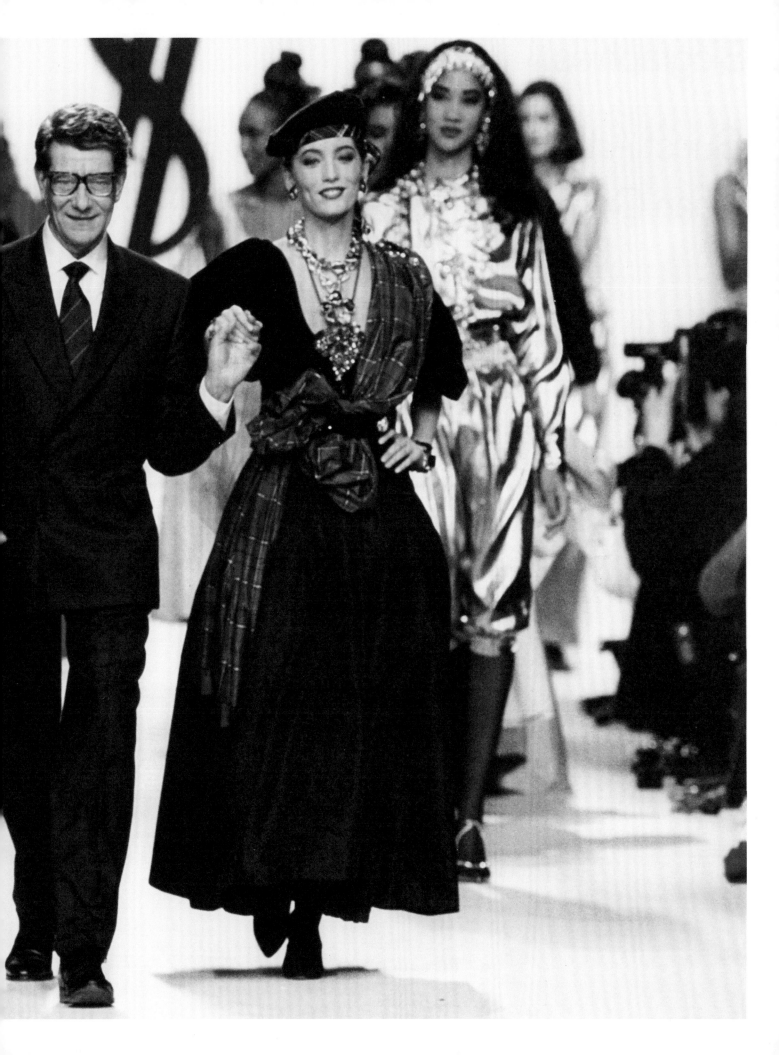

Biographies

Guest Artist

Johan Creten

A pioneer of the revival of ceramics in contemporary art, the Paris-based Belgian artist Johan Creten has been touring for nearly forty years, from Mexico to Miami to the Hague. In his creative process, Johan Creten evokes Slow Art. His representations of the world are filled with poetry, lyricism, and mystery. His handcrafted wall sculptures pursue geometric perfection. His work in clay and gold resonates with the daytime jewels of golden buttons so cherished by Yves Saint Laurent.

About the Contributors

François-Marie Banier

François-Marie Banier is a novelist, painter, and photographer. As a friend of Yves Saint Laurent since 1969, he was welcomed by the couturier into the couture house and ateliers, and he became a privileged witness to the preparation of the collections and fashion shows.

Marisa Berenson

Maria Berenson is a famous model and actress and granddaughter of Elsa Schiaparelli, the fashion designer who made her mark on the twentieth century and who was especially important to Yves Saint Laurent. Marisa Berenson was greatly admired by the couturier.

Joan Juliet Buck

Editor in chief of *Vogue* (Paris) from 1994 to 2001, Joan Buck is a writer and critic. A fervent admirer of Yves Saint Laurent's creations, she frequented the world of Parisian haute couture and developed a detailed knowledge of the philosophy of the fashion industry. She forged a bond with the couturier while She conducted many lengthy interviews with him in the '70s and '80s.

Gabrielle Busschaert

Gabrielle Busschaert was Yves Saint Laurent's collaborator at Dior. She followed him when he decided to open his own couture house in 1961 and became head of press services. She worked there until 1996.

Betty Catroux

Betty Catroux met Yves Saint Laurent in 1967 in the famous Chez Régine nightclub. The young woman and Yves began a tight-knit friendship. Her androgynous look embodied a certain feminine ideal for the couturier, and she became his muse.

Vincent Darré

Vincent Darré was a stylist and interior decorator who began in the fashion world by working for major French labels, including Yves Saint Laurent. In the 2000s, he founded his own company, Maison Darré. Since 2008, he has focused exclusively on the creation of furniture and decorative objects.

Dominique Deroche

Dominique Deroche arrived in 1966 as Gabrielle Busschaert's assistant and became director of the company's press service in 1996. In 2004, when the couture house was transformed into a foundation under the initiatives of Pierre Bergé, she continued to contribute to the influence of Yves Saint Laurent's creations.

Jacques Grange

Decorator and interior designer Jacques Grange met Yves Saint Laurent and Pierre Bergé at the age of twenty-eight and became friends with the couple. He conceived many projects for them, including the decor of the couture house at 5 avenue Marceau, in Paris. He also created the emblematic interiors at Château Gabriel in Benerville-sur-Mer, which he designed in a Proustian style inspired by *In Search of Lost Time*, as well as the decor for the Villa Majorelle in Marrakech and the Villa Mabrouka in Tangier.

Anna Klossowski

Daughter of the writer Thadée Klossowski and the designer Loulou de La Falaise, Anna Klossowski grew up as part Yves Saint Laurent's entourage. The designer was her godfather. As a child, Anna's mother often took her to visit him and Pierre Bergé. She is now a curator of contemporary art and cofounder of We Do Not Work Alone, a publishing house for usual objects designed by artists in limited series.

Alexis Kugel

With his brother Nicolas, Alexis Kugel is part of the fifth generation of a family of antique dealers and collectors who came to Paris in 1924. Yves Saint Laurent and Pierre Bergé were loyal to this art gallery for many years.

Paloma Picasso

Fashion and jewelry designer Paloma Picasso is the youngest daughter of Pablo Picasso and Françoise Gilot. Shortly before her twentieth birthday, she met Yves Saint Laurent, with whom she became friends, a friendship animated by a lively and mutual aesthetic affinity. The couturier testified to the influence she had on his spring/summer 1971 haute couture collection, known as "Quarante," considered scandalous by the press.

Françoise Picoli

Françoise Picoli joined Yves Saint Laurent in 1977 as a stylist. She soon became a shoe designer. She worked with the shoe atelier and factories for haute couture and ready-to-wear shows as well as for distribution. Starting at the end of the 1980s, she was the leather accessories collections director until 2000, overseeing a team dedicated to the development of international licenses.

Clara Saint

Director of communications for SAINT LAURENT *rive gauche* starting in 1966, Clara Saint was a close friend of Yves Saint Laurent and Pierre Bergé, with whom she visited the many artists of her time, including Andy Warhol.

Violeta Sanchez

Violeta Sanchez was an actress and performer who enjoyed a long career as a model for Yves Saint Laurent. She joined the couture house in 1979 as a model and participated in many fashion shows up to the 2002 retrospective organized at the Centre Pompidou.

This book has been published as part of the exhibition

GOLD
by Yves Saint Laurent

presented at the Musée Yves Saint Laurent Paris October 14, 2022 to May 14, 2023.

The entire project was supported by the Fondation Pierre Bergé–Yves Saint Laurent, headed by Madison Cox.

The articles on display belong to the unique heritage left by Yves Saint Laurent and Pierre Bergé at the closing of the haute couture house in 2002, for which the Fondation, officially recognized as a public service organization, ensures their conservation and prestige.

EXHIBITION

Head Curator
Elsa Janssen
Director of the Musée Yves Saint Laurent Paris

Scientific Curatorship
Alice Coulon-Saillard
Domitille Éblé
Judith Lamas
Sylvie Marot

Artistic Committee
Anna Klossowski
Valérie Weill

Guest Artist
Johan Creten

Scenography
Jasmin Oezcebi

Sound Design
Pierre-Arnaud Alunni

Graphics
Charlotte Sobral Pinto

ACKNOWLEDGMENTS

For their generous loans, we extend our sincere thanks to:
Betty Catroux
Johan Creten
Galerie Kugel
Saint Laurent
Yves Saint Laurent Beauté
Galerie Perrotin
Maison Lesage
Sylvie Vartan

For their valued contributions, we thank:
François-Marie Banier
Marisa Berenson
Joan Juliet Buck
Gabrielle Busschaert
Betty Catroux
Vincent Darré
Dominique Deroche
Jacques Grange
Yvane Jacob
Alexis Kugel
Anna Klossowski
Paloma Picasso
Clara Saint
Violeta Sanchez

All contributions featured in this book, excluding those by Yves Saint Laurent and Pierre Bergé, were collected during interviews by Yvane Jacob and Elsa Janssen between June and August 2022.

Lastly, we extend our thanks to:
Maxime Catroux
Alexis Sornin

MUSÉE YVES SAINT LAURENT PARIS

Madison Cox
President

Elsa Janssen
Director

Laurent Gardette
Administrative and Financial Director

Conservation
Serena Bucalo-Mussely
Collections Supervisor
Alice Coulon-Saillard
In charge of photographic, audiovisual, and press archives collections
Domitille Éblé
In charge of graphic arts collections
Judith Lamas
In charge of textile and accessories collections
Sylvie Marot
Curatorship Project Manager
Clémentine Cuinet
In charge of photographic collections
Blandine d'Huart
In charge of accessories collections
Olivia Klusiewicz
In charge of inventory for graphic arts collections
Mahayana Callewaert
Marie Baret
Interns

Collections and Exhibitions Management
Tiphanie Musset
Head of the Management Department for Exhibitions and Collections
Nora Evain-Bentayeb
Attaché to the Management Department of Exhibitions and Collections
Léa Denys
Assistant to the Management Department of Exhibitions and Collections
Enora Mérel
Intern

Public Sector
Mélanie Scavetta
Responsible for public sector
Aglaé Marit
In charge of public sector and bookstore

Communications
Claire Schillinger
Head of Communications
Marie Delas
Project Manager
Romane Lair
Communications Assistant
Prune Sommier
Communications Intern

Administrative Services
Bénédicte Segré
Administrative Manager and Accountant
Olivier Chauffeton
General Services Attaché
Maria Ribeiro
Administrative Attaché
Oliver Paulhac
Information Technology Manager

CATALOG

Editor
Elsa Janssen

Editorial Coordination
Marie Delas
Sylvie Marot

Authors
Forewords and Essays
Madison Cox
Joan Juliet Buck
Elsa Janssen
Yvane Jacob

Editor of Announcements Documentary and Iconographic Research
Alice Coulon-Saillard (A. C.-S.)
Clémentine Cuinet
Marie Delas (M. D.)
Domitille Éblé (D. É.)
Olivia Klusiewicz
Judith Lamas (J. L.)
Sylvie Marot (S. M.)

Photographs
Matthieu Lavanchy

Set Design
Valérie Weill

Graphic Design and Layout
Sarah Martinon

Éditions Gallimard
Nathalie Bailleux
Editorial Director of Illustrated Books
Astrid Bargeton
Editor
Anne-Claire Juramie
Proofreader
Anne Lagarrigue
Artistic Director
Pascal Guédin
Coordinator, Illustrated Books
Franck Fertille
Director of Partnerships
Caroline Levesque
Partnerships
Amélie Airiau
Production Manager
Cécile Lebreton
Production
Béatrice Foti,
assisted by
Coline Birette
Press
Mathilde Barrois,
assisted by
Coline Briand
Co-editions

189

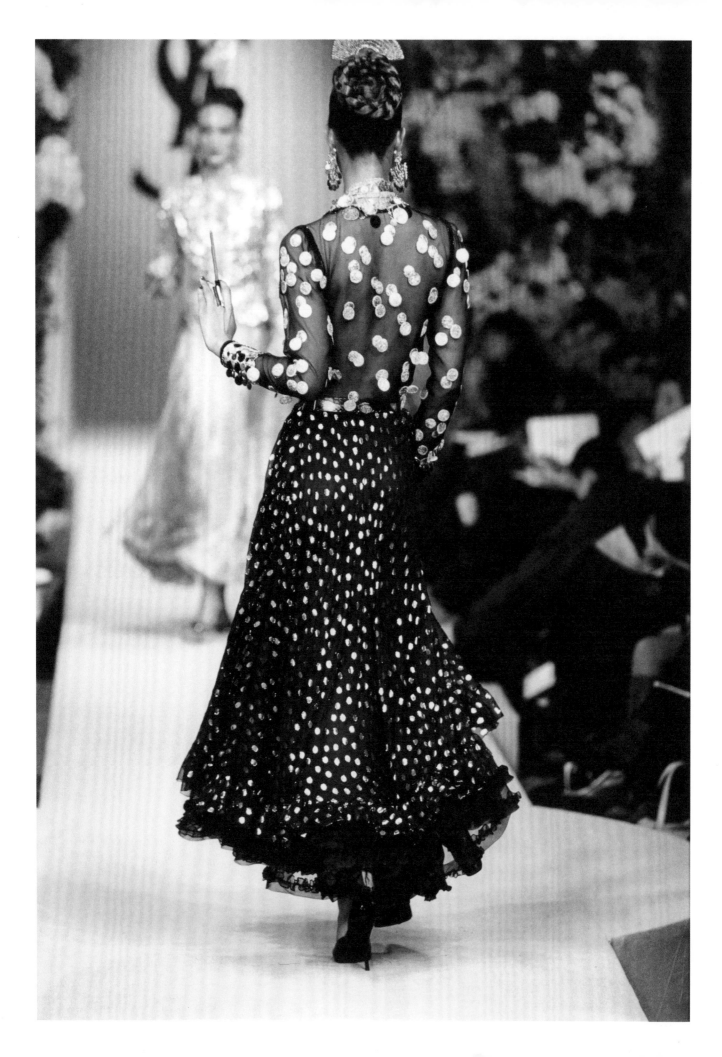

Photo Credits

© Adagp, Paris, 2022
For the work of César: p. 27
For the works of Claude Lalanne: p. 70-71, 73, 74

© Arthur Elgort / Condé Nas: p. 45 © Bertrand Rindoff Petrof: p. 180-181 © Creten Studio & Galerie Transit © Creten & Gerrit Schreurs: p. 13 © David Bailey—*Vogue Paris*: p. 152, 155 © David Bailey: p. 77 © David Seidner: p. 20 © Maurice Bensimon: p. 174-175 © Michel Dufour / WireImage: p. 160-161, 163 © Musée Yves Saint Laurent Paris / Matthieu Lavanchy: p. 10, 33, 41, 49, 55, 65, 68, 69, 73, 74, 85, 86-87, 92, 100-101, 103, 107, 123, 126-127, 137, 148, 149, 150-151, 157, 164, 173, 183 © Nadia Rein—Rights reserved: p. 57 © Norman Parkinson / Condé Nast: p. 37 © Patrice PICOT/GAMMA RAPHO: p. 104-105 © Patrick Jarnoux / Paris Match: p. 131 © Patrick Lichfield: p. 143 © Philippe Morillon: p. 166-167, 170 © The Helmut Newton Estate / Maconochie Photography: p. 14 © The Helmut Newton Estate / Maconochie Photography / Condé Nast: p. 43 © The Helmut Newton Estate / Maconochie Photography / Yves Saint Laurent Paris: p. 145 © Trunkarchives / Lord Snowdon: p. 5 © Vladimir Sichov: p. 25 © Yves Saint Laurent: p. 32, 36, 58, 59, 62, 67, 94, 95, 98, 109, 114, 115, 125, 128, 141, 178, 179 © Yves Saint Laurent / Claus Ohm: p. 6, 19, 53, 61 © Yves Saint Laurent—Rights reserved: p. 51, 52, 63, 89, 159, 190 © Yves Saint Laurent / François-Marie Banier: p. 31, 38, 116, 119 © Yves Saint Laurent / Frédéric Bukajlo: p. 78 © Yves Saint Laurent / Guy Marineau: p. 47, 91, 97, 111, 113, 120, 168 © Yves Saint Laurent / Jacques Verroust: p. 82 © Yves Saint Laurent / Nicolas Mathéus: p. 35 Rights reserved: p. 50, 132, 136, 139, 146, 177, 184-185 Photo © Musée d'Orsay, Dist. RMN-Grand Palais / Patrice Schmidt: p. 28-29 / © Jean-Philippe Lalanne p. 70-71

All reasonable efforts have been made to identify the rights holders. Errors and omissions reported to the editor will be corrected in subsequent editions.

On the cover:
Evening dress worn by Christa Fiedler, fall/winter 1966 haute couture collection. Photograph by David Bailey. © David Bailey—*Vogue Paris*

Photoengraving: Les Caméléons, Paris

Copyright © 2022 Musée Yves Saint Laurent Paris
English translation copyright © 2023 Abrams

Translated from the French by Zach Townsend, Townsend Language Services

Library of Congress Control Number: 2023932511

ISBN: 978-1-4197-7140-8

Originally published in France in 2022 by Éditions Gallimard.

Printed and bound in China
10 9 8 7 6 5 4 3 2 1

Abrams books are available at special discounts when purchased in quantity for premiums and promotions as well as fundraising or educational use. Special editions can also be created to specification. For details, contact specialsales@abramsbooks.com or the address below.

Abrams® is a registered trademark of Harry N. Abrams, Inc.

ABRAMS The Art of Books
195 Broadway, New York, NY 10007
abramsbooks.com

Chiffon, Romani-style dress worn by Georgianna Robertson,
spring/summer 2000 haute couture collection.

"One day, I will have my name inscribed in gold letters on the Champs-Élysées."

Yves Saint Laurent